D0053186

4-H GUIDE
TO DIGITAL PHOTOGRAPHY

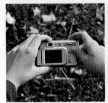

Daniel Johnson

Voyageur Press

A portion of the sales of this product will be used to promote 4-H educational programs. No endorsement of this product by 4-H is implied or intended. Use of the 4-H Name & Emblem is authorized by USDA.

4-H is a community of six million young people across America learning leadership, citizenship, and life skills. National 4-H Council is the private sector, non-profit partner of National 4-H Headquarters (USDA). The 4-H programs are implemented by the 106 Land-Grant Universities and the Cooperative Extension System through their 3,100 local Extension offices across the country. Learn more about 4-H at www.4-H.org. 18 USC 707

First published in 2009 by Voyageur Press, an imprint of MBI Publishing Company, 400 First Avenue North, Suite 300, Minneapolis, MN 55401 USA

The information in this book is true and complete to the best of our knowledge. All recommendations are made without any guarantee on the part of the author or Publisher, who also disclaims any liability incurred in connection with the use of this data or specific details.

We recognize that some words, model names, and designations mentioned herein are the property of the trademark holder. We use them for identification purposes only.

Voyageur Press titles are also available at discounts in bulk quantity for industrial or sales-promotional use. For details write to Special Sales Manager at MBI Publishing Company, 400 First Avenue North, Suite 300, Minneapolis, MN 55401 USA.

To find out more about our books, visit us online at www.voyageurpress.com.

Library of Congress Cataloging-in-Publication Data

Johnson, Daniel, 1984-
 4-H guide to digital photography / by Daniel Johnson.
 p. cm.
 Includes index.
 ISBN 978-0-7603-3652-6 (flexibound)
 1. Photography—Digital techniques. 2. Image processing—Digital techniques. I. National 4-H Club Foundation of America. II. Title.
 TR267.J638 2009
 775—dc22
 2009014679

Edited by Danielle Ibister
Design Manager: Katie Sonmor
Series designed by Pauline Molinari
Layout by Barb Drewlo
Cover designed by the Book Designers
Front cover main image: © Shutterstock

Printed in China

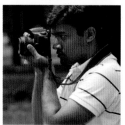

CONTENTS

Acknowledgments

I would like to thank the following people who were particularly helpful during the process of writing and photographing this book: My editors, Amy Glaser, for her continued help and enthusiasm, and Danielle Ibister, for her help and encouragement. Everyone at Voyageur Press, for the opportunity to write about my favorite subject—thank you! Lorin, Paulette, and Samantha, for long hours spent proofreading the manuscript and offering many great ideas. Emily and Anna, for helping with and appearing in many of the photos. J. Keeler, for some advice on the more technical portions of the book, and for assistance with many of the pictures, especially those of the cameras themselves. W. O. P., for sharing his vision.

&

To Josh, my camera buddy

&

"The idea occurred to me—how charming it would be

if it were possible to cause these natural images to

imprint themselves durably and remain fixed on paper."

—William Henry Fox Talbot (1800–1877), inventor of
the positive/negative process of photography

WELCOME TO DIGITAL PHOTOGRAPHY

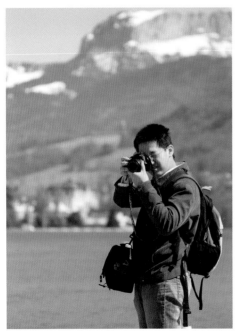

Photography is the most popular 4-H project—and this book will put you well on your way to becoming an excellent photographer. *Shutterstock*

Welcome to the world of digital photography! In this book, I hope to present a fun and informational look at the basics of good photography and digital photo management, as well as some more advanced techniques to boost your skills. Photography is a wonderful way to create art, preserve memories, and have fun, all at the same time. Digital photography can help us to do all of these things even better than ever.

Photography is the most popular 4-H project, and many participants enjoy entering their photography in competitions, whether it's at the county fair or in other type of contests. Those interested in competition will definitely want to study chapter 3, which describes many ways to make your photos more attractive, and chapter 9, which describes making prints and includes some winning tips. Elsewhere, we'll take a look at different camera types, various lighting situations, solutions to common problems, and some fun ideas that you may not have heard of before. I hope you enjoy reading this book as much as I've enjoyed writing and photographing it. I was involved with 4-H for many years, and photography was my favorite project. I started entering my photos

Throughout this book, we'll explore various lighting techniques that you can apply to your own photographs. This photo uses the backlighting style.

in the county fair when I was eight years old and, later, won my first Best of Show award with a photograph of an old barn. (Actually, old barns are still one of my favorite subjects to photograph.) When I was fourteen, my 4-H photography project was to take one special photograph every day for ninety days, and also to write a brief description of each photo. It was a fascinating project that I greatly enjoyed, and I like to think that my early days in 4-H encouraged me in my choice of profession as a photographer today. I hope I can encourage you in your photography pursuits as well.

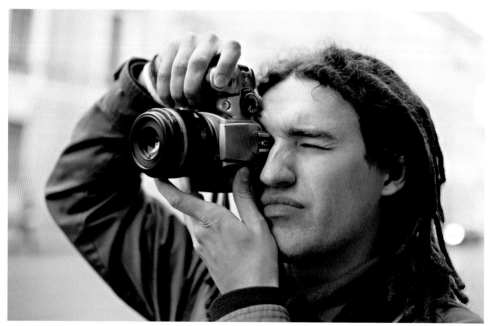

Most good photos come from having a solid understanding of camera controls, composition, lighting, and timing. We will discuss all of these topics in detail, as well as some ideas for having fun with your camera. *Shutterstock*

An Incredibly Brief History of Digital Photography

The beginning of digital photography is hard to pin down exactly. Photography itself—in the film-based form—had its start in the first half of the 1800s, with black-and-white processes. Color film didn't become widespread until the 1930s, and film has continued to improve in appearance ever since. Digital photography had its start, in a way, with the invention of television in the 1920s because for the first time images were created on a screen using dots of varying brightness (called *pixels*). Digital photography as we know it today was developed, in part, as a result of the space age, when scientists needed a method to retrieve photographs that were taken in space by satellites that wouldn't be returning to Earth, and therefore couldn't bring back a roll of film. These satellites beamed the digital photos back to Earth in the form of radio signals, in much the same way that you can e-mail a photo today. But it took until the late 1990s before digital cameras were developed that were small enough in size and high enough in quality to be popular among everyday photographers.

> Digital photography as we know it today was developed, in part, as a result of the space age, when scientists needed a method to retrieve photographs that were taken in space by satellites that wouldn't be returning to Earth, and therefore couldn't bring back a roll of film.

Read This, Even If You Don't Read Anything Else

If you're the type of person who isn't going to really read this entire book and is only going to flip through it and look at the pictures and read the captions, you should at least read this part: my top five tips for better photos. These tips and many others will be discussed in far more detail later on, but just to start things off, remember to always do the following:

- **Shoot every photo at your camera's highest quality setting.** This way, whenever you get a fantastic image, it will be of a quality that's high enough to reproduce as a big print later on. You can always make a small copy of a good picture later to e-mail or whatever, but

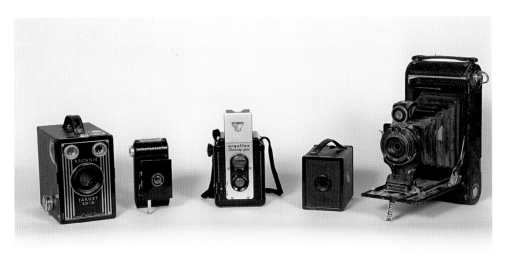

Here's a selection of old cameras that I've collected over the years, purchased from garage sales and antiques stores. It's fascinating to see how cameras and photographic techniques have changed over time.

if you shoot the picture at a low quality to begin with, it will be trapped like that forever.

- **Press the shutter button down halfway and then wait—poised—until the perfect moment is ready.** This way, you can get rid of the annoying way that a camera has of hesitating before taking a picture, just when something good is happening. Most of what people refer to as "shutter lag" is actually the camera performing autofocus and flash charging. If you have these tasks taken care of ahead of time—by keeping the shutter pressed down halfway—the camera will be ready to fire at a moment's notice.

- **Get in close!** Many photos are ruined because the photographer was too far away from the subject. Move in (either by zooming or by actually walking closer) and fill up the whole picture with that dog, or that house, or that friend. Chapter 2 talks more about this.

- **"Save As!"** Whenever you experiment with adjusting your photo using image-editing software, don't use the Save command, which replaces the original file. Instead, be sure to use the Save As command to make a new copy of your photo with a new name. This way, if you happen to make a mistake or change your mind later, you can always go back to the original photo and start over.

- **Trash the flash!** Flash pictures are often unattractive unless you have had plenty of practice, so turn off the flash until you get the hang of things. Chapter 4 talks all about using flash.

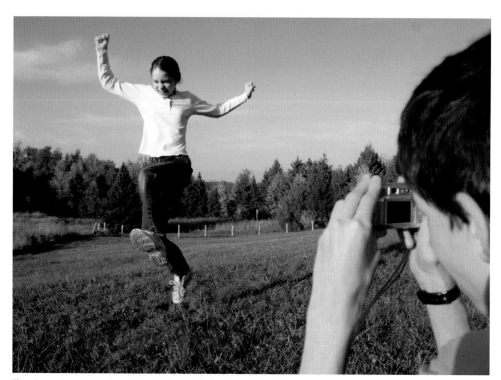

Shooting action pictures is much easier if you take the time to learn how your camera operates and how quickly it responds to your commands. As with many things, practice is the key to good photography.

Careers in Photography

There are many types of jobs in the world of photography, and I've included a short list of some of them here. Not all of these will interest you, but you may want to keep in mind some of the jobs you find most appealing as you explore photography throughout this book.

- **Wedding photographer:** Wedding photographers must be organized and efficient in order to capture perfectly all the important moments of a busy, memorable day—where there are no chances to go back and get the shot again.

- **Portrait photographer:** Portrait photographers specialize in taking pictures of people, either in a studio or outdoors. They must excel in making people feel relaxed and comfortable while they are having their photo taken.

- **Pet photographer:** Good pet photographers need to love and understand animals well. They need to be able to get close to the animals, down on the floor or ground, and always keep a good sense of humor.

- **Landscape/nature photographer:** Nature photographers should enjoy working outdoors and spending a lot of time traveling on foot to find the best location or angle for a particular shot. They have to be able to work in all kinds of weather.

- **News photographer/photojournalist:** News photographers must be ready at all times to rush out to a particular scene where news is taking place. They have to be adept at photographing all kinds of subjects in all kinds of situations.

- **Sports photographer:** Sports photographers have to know their equipment and their chosen sport very well. They have to be quick and ready, always poised and able to anticipate the perfect moment.

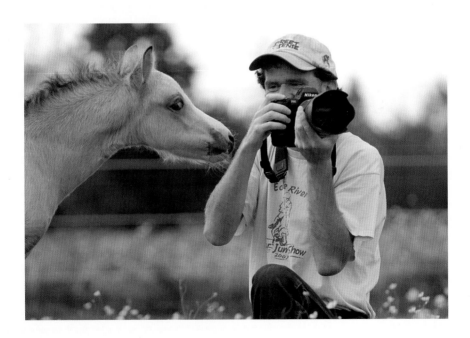

EXPLORING DIGITAL CAMERAS

concern ourselves with those in this book. Let's take a quick run through the features that you will find on any digital camera, and then we will examine both types more closely.

T o begin with, it's important to understand that there are two basic groups of digital cameras: one type features a built-in lens that you cannot change, and the other type accepts various kinds of lenses that you can change. The first group of cameras—and certainly the most common—are known as *point-and-shoot* cameras. The second group—used by most professional photographers and advanced amateurs—are known as Digital Single Lens Reflex cameras, or *DSLRs*. There are exceptions, of course, but when you get right down to it, you can pretty much classify any digital camera into one of these two groups, except for some very high-end specialty cameras known as medium-format digital cameras. We needn't

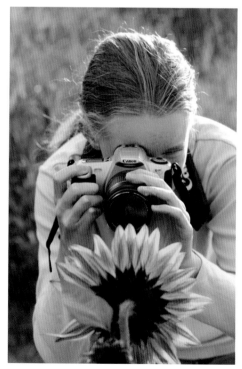

A DSLR (Digital Single Lens Reflex) camera gives the photographer excellent image quality, as well as the chance to try out various lenses in various situations.

Digital point-and-shoot cameras (*left*) can make great pictures, but they have limited capabilities. The DSLR models (*right*) are more powerful and allow more creative options, but they are heavier and more expensive.

All digital cameras share some basic parts:

- **Sensor:** The sensor is a small, rectangular object inside the camera. It turns light into electronic signals, which the camera then uses to form your digital image. The sensor sits in exactly the same position that film does in a film camera, right behind the lens.
- **Shutter:** The shutter is a curtain in front of the sensor, like a curtain in front of a window. It blocks light from reaching the sensor until you're ready to take a picture.
- **Shutter button:** This is the button you press to take a picture. Pressing it causes the shutter to open and allows light to pass through the camera and onto the sensor.
- **Lens:** The lens is the camera's "eye." It gathers light from a scene, focuses it, and delivers it to the inside of the camera.

- **Built-in flash:** Many cameras have a built-in flash used for adding light to a scene that is too dark, but when used incorrectly, a flash can make an otherwise-good photo look bad.
- **Card slot:** The card slot holds the camera's digital memory card, where all the images are stored as digital files.

Point-and-Shoot Digital Cameras

Point-and-shoot digital cameras are just what they sound like: you point them, you press the shutter button, and the camera shoots a picture without asking any further questions. Point-and-shoot cameras have always been popular with everyday picture-takers, for good reason. They're always cheaper than a more sophisticated camera, they (usually) take decent pictures, and you don't have to know much about photography to use them.

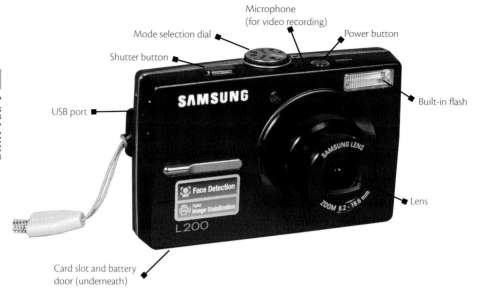

Microphone
(for video recording)

Mode selection dial

Power button

Shutter button

USB port

Built-in flash

Face Detection
Digital Image Stabilization

SAMSUNG LENS

ZOOM 6.2 - 18.6 mm

Lens

L200

Card slot and battery
door (underneath)

Here are some of the most common features of a point-and-shoot camera. Your particular model may or may not share all of these features.

You can recognize a point-and-shoot camera right away by its physical characteristics:

- **Small size.** I'll be the first to admit it: Having a small camera is convenient. Because they don't take up much space or weigh much, and because it's easy to bring them along wherever you go, you are much more likely to have the camera on hand when a good photographic opportunity presents itself. The biggest, greatest camera in the world does you no good if it's sitting at home under the bed, because it was too heavy and cumbersome to take along with you.

- **Built-in lens.** There's no need to worry about which lens to bring along with a point-and-shoot camera because you always have it with you! The built-in lens is usually a small zoom, often able to produce a decent range of perspectives. This range is broad enough to give you some basic creative options, from wide-angle landscape pictures to pleasing portraits. Some built-in lenses even offer macro capabilities for close-up work.

- **LCD.** It seems that everyone likes to take pictures using the little screen, called the liquid-crystal display (LCD), on the back of the camera. This technique is usually called "live view" (because the screen allows you to view what is happening live, right now). Sometimes this is a good idea, and sometimes it has disadvantages.

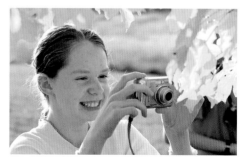

A digital point-and-shoot camera has everything you need in a small, lightweight package. This girl is using the LCD to compose a close-up (macro) photograph of some beautiful autumn leaves.

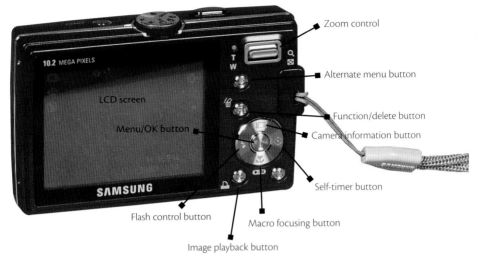

Zoom control

Alternate menu button

10.2 MEGA PIXELS

Function/delete button

LCD screen

Camera information button

Menu/OK button

SAMSUNG

Self-timer button

Flash control button

Macro focusing button

Image playback button

You will want to become familiar with all of the controls and features on your camera so that you will know where everything is and be well prepared when an exciting photographic opportunity presents itself.

For instance, if you are outside taking pictures in bright sun, the LCD may be too dim to see clearly, making it impossible to get good pictures. Or if you're taking pictures of rapidly moving objects like people or animals, it may be too hard to follow the action with an LCD. Use your camera's regular viewfinder (if it has one) in these situations. In addition to using the LCD as a digitized viewfinder, photographers also use it to view the pictures they've recently taken and to access various camera setup menus.

- **Built-in memory.** Most point-and-shoot digital cameras have a small amount of memory built into them, enough to hold a handful of pictures. A memory card can be added that holds many more pictures. The idea is that if you somehow forgot your memory card at home—or if it was full—and some incredible photo opportunity appeared before you, you wouldn't be out of luck.

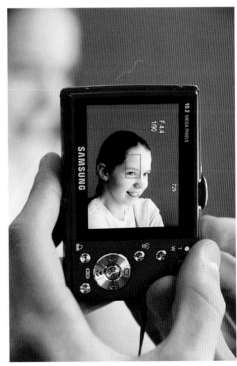

All point-and-shoot digital cameras allow the photographer to arrange photos using the LCD screen. The size of the LCD screen may play a part in your choice of cameras; a larger LCD makes for easier viewing.

13

What about My Camera Phone?

The camera in your cell phone is a kind of point-and-shoot camera, but it's one I wouldn't recommend using for any serious work. They're fine for silly pictures of you and your friends making faces, or those "here-I-am-standing-in-front-of-the-Empire-State-Building" tourist shots, but beyond that, they're fairly weak cameras. You're going to want to use something with a little more creative power. Phones are designed to be phones first and cameras second, and many of the features that are necessary to use your camera to the fullest are buried away in menus, if they exist at all. Also, a camera phone's lens is incredibly small and cannot deliver high optical quality. Keep your camera phone for fun stuff, but don't make it your first choice for real photography.

On the other hand, if a UFO suddenly appears, hovering above the street, and the only camera around is on your phone—start shooting!

Quick Tip: Digital Zoom

When you are looking to purchase a point-and-shoot camera, the packaging may advertise a "digital zoom" feature with numbers like "4x Digital Zoom" or "5x Digital Zoom." It's best to ignore these numbers and instead check the camera specifications to find out what the camera's *optical* zoom is. The difference between these two is that the optical zoom number represents how much power the lens actually has, and this is the number you need to look at when comparing different models. Digital zoom is kind of a tricky way for camera manufacturers to put another number on the box, in addition to the optical zoom number. Digital zoom isn't really a zoom at all; it works by cropping and blowing up big a very small piece of the picture. This has a very degrading effect on the photo and shouldn't be used in most situations.

Video

Many point-and-shoot cameras can also make video clips, saving the video right on the same card as your pictures. I love shooting videos, and I love having the option of shooting clips with a digital camera. The quality of the video clips can vary from model to model, but I've had fairly good success overall. It's a fun feature, although you probably won't want to film anything lengthy with a digital camera. Be aware that, on some cameras, you won't be able to zoom in and out or change focusing once the video has started recording, so be sure to set these options ahead of time.

Remember, video eats up memory space very quickly, with every minute of video footage taking up space on the card that might otherwise be used for pictures. Don't leave yourself short on space if your card is nearly full; you don't want some great photo opportunity to appear just as you've filled your card with video!

Disadvantages

So, if point-and-shoot cameras are so great and wonderful, why would anyone use anything else? Why do pro photographers lug around expensive, heavy cameras and a bagful of lenses everywhere they go? The answer, of course, is to get better pictures.

For all their advantages, tiny point-and-shoot cameras fall short in many major categories when it comes to delivering top-quality images. For example, point-and-shoot cameras have the following:

- **High noise.** Point-and-shoot digital cameras always have more noise than

Remember, video eats up memory space very quickly, with every minute of video footage taking up space on the card that might otherwise be used for pictures.

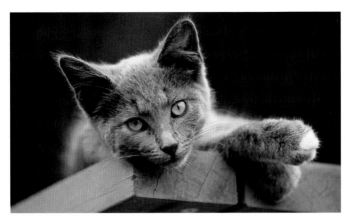

This photo uses selective focus to draw the viewer's attention to the kitten. Only the kitten's face and paws are in sharp focus, while the tabletop and the rest of the background falls away into a pleasing blur. Point-and-shoot cameras have a difficult time achieving this effect, while DSLRs excel at it.

larger cameras. Noise occurs when the camera overcompensates for low lighting, creating tiny bits of grain and colored speckles that reduce the clarity of the picture. (See the "Digital Noise" [page 20] and the "My Pixels Are Better than Your Pixels" [page 21] sidebars for more information.) This is a major drawback no matter what kind of photography you do.

- **A wide depth of field.** This means it is almost impossible for the camera to use *selective focus*, a term used to describe a photograph where the main subject is quite sharp but the background is out of focus. This is a very beautiful technique but one that point-and-shoot cameras are not capable of producing.

- **Slow speed.** Point-and-shoot cameras are not very fast. They don't autofocus quickly, they don't charge their flashes quickly, and they can't fire off a whole string of photos when something exciting happens. They just don't react quickly to fast situations.

- **Important features that are unavailable or hidden in menus.** It can be very annoying when you need to turn on a particular feature *right now* while something good is happening, only to find that the "white balance" or the "ISO" settings, for example, are buried away in layers of camera menus. By the time you find the feature you need, the special moment has passed. These features are much more accessible on a DSLR.

This photo illustrates a very wide depth of field, meaning that everything in the photograph is sharp, from the shoes all the way to the distant tree line. Point-and-shoot cameras have an easy time creating this effect.

Here is a look at some of the most common features, dials, and parts of a DSLR camera and lens. Learning to use everything may seem overwhelming, but don't let the array of buttons discourage you.

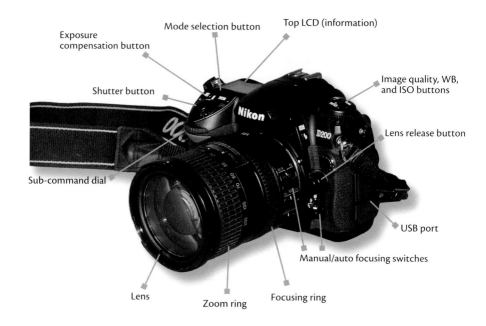

Mode selection button

Top LCD (information)

Exposure compensation button

Image quality, WB, and ISO buttons

Shutter button

Lens release button

Sub-command dial

USB port

Manual/auto focusing switches

Lens

Zoom ring

Focusing ring

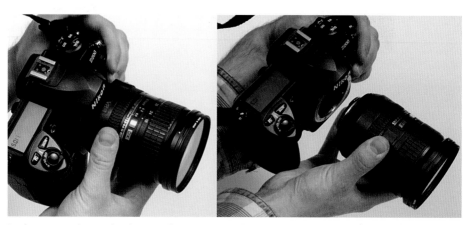

Read your camera's manual to determine how to mount and remove a lens from your DSLR properly. Also, try not to leave your camera without a lens for very long, since dust may creep into the mount and settle on the sensor.

This rear view of a DSLR shows more buttons and dials, as well as the LCD screen. Some DSLRs do not allow the photographer to use the LCD screen as a viewfinder. Instead, you have to work with the more traditional optical viewfinder, which offers a sharper, more accurate view of your scene.

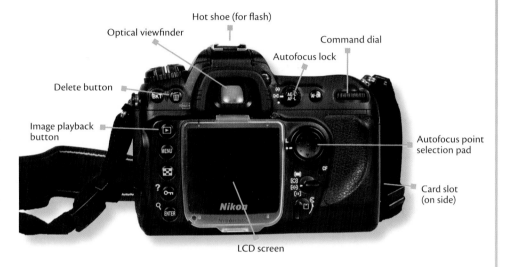

Hot shoe (for flash)

Optical viewfinder

Command dial

Autofocus lock

Delete button

Image playback button

Autofocus point selection pad

Card slot (on side)

LCD screen

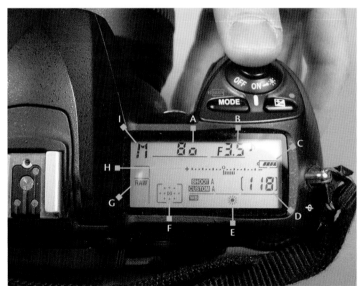

A Shutter speed

B Aperture setting (f/stop)

C Battery level

D Number of pictures remaining

E White balance setting

F Active focusing point

G Image quality

H Exposure compensation graph

I Current mode

In addition to the large LCD screen on the back, DSLR cameras also have a small LCD screen on the top that is used to display information—not images—to the photographer.

DSLRs

Point-and-shoot cameras are nice and can produce nice images, but for the reasons I just mentioned and others, I would not encourage you to pursue your photography dreams using one. If at all possible, I would recommend that you work with a DSLR camera. You may not have a choice in the matter if the cost difference between the two types is an issue. But if you can afford the initial investment of a DSLR, you will find yourself taking far more successful, beautiful pictures.

Some photographers say things like, "It's not about the camera; only the photographer matters," or "The camera is only a tool; all that matters is how the photographer uses it." True, the person is more important than the tool. But good tools can help good photographers make good pictures even better, and in the case of something as fundamental to photography as the camera itself, the tool we're talking about is extremely important. For this reason, I believe that anyone with a passion for photography should bypass the point-and-shoot route and buy a DSLR. The difference between the two is significant. There are some areas where DSLRs simply hold the advantage, such as the following:

- **Interchangeable lenses.** A DSLR body can have its lens easily removed and swapped with one of a different length. This gives you almost unlimited options in the perspectives you can achieve. (Of course, "all-in-one" lenses like the kind on a point-and-shoot also exist for DSLRs, for the sake of convenience.) Also, the optical quality of a large lens designed for a DSLR is far better than the quality of a tiny lens built into a point-and-shoot.
- **Limited noise.** DSLRs won't generate as much noise in your images as a point-and-shoot. This is partly because of the better light sensors and partly because DSLR cameras sometimes apply noise-reduction technology to your image just after you take it.
- **Speed.** While the exact speeds vary from model to model (with the fastest speeds saved for the top-end pro varieties), DSLRs of all types can deliver quick autofocusing and fast frame rates. A fast frame rate means you can shoot off three, four, five, or even more images every second. This is useful in countless situations where you are photographing action, since you are almost guaranteed to get at least one image that was taken at exactly the right instant. Less-than-perfect images can then be deleted.
- **Durability.** DSLRs are tough, especially the good ones. Although the very basic beginner models may be made of plastic, many DSLRs are made of some kind of metal, such as magnesium-alloy. Many models incorporate weather sealing to help ensure that the camera will not malfunction if it gets slightly wet or has to operate in difficult weather. All of this together means that a DSLR will probably last longer than a point-and-shoot.
- **Optical viewfinder.** With a DSLR, you don't usually look at an LCD screen when taking your photos. (Most DSLRs don't offer live view at all.) Instead, you look through an optical viewfinder that shows exactly what the lens is currently seeing. Although you may not think so at first, using an optical viewfinder has some huge advantages over an LCD screen. For one thing, it is very sharp, bright, and clear, making it easy to arrange your photograph. Second, it works perfectly outside in bright light, when an LCD screen might become difficult to see. Third, if you take action pictures of moving objects where you need to pan along with the subject, an optical viewfinder will give you far superior results over an LCD.

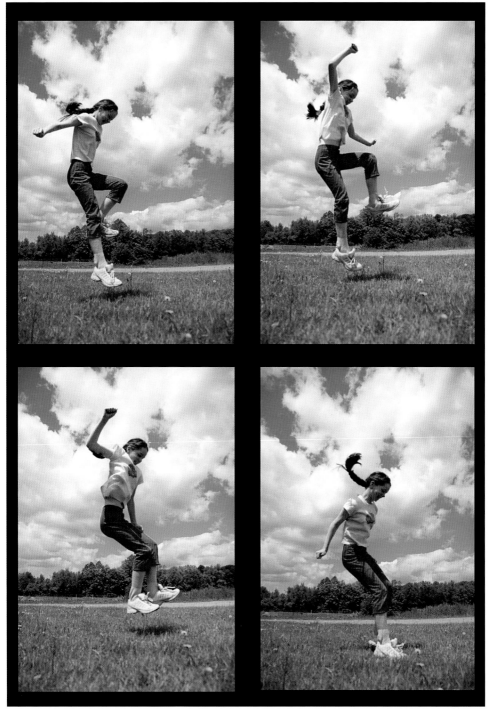

DSLR cameras are fast, and they're great for working with fast-moving subjects. For this series of images, I simply held down the shutter button as the girl jumped, so the camera fired off a rapid burst of photos. The result is an interesting sequence showing all phases of the action. I used a wide-angle lens to take in the whole scene and make the jump appear more exaggerated then it really was.

Digital Noise

What is noise? When talking about digital cameras, the term "noise" refers to the little multicolored dots that may appear in certain pictures taken under certain situations. For instance, a picture taken in very low light will always have more noise than one taken under normal lighting conditions. What causes it?

Think of a sound recording of something very quiet, like a person whispering. You can't quite hear what the person is saying, so you turn up the volume. In digital terms, "turning up the volume" amplifies the signal. This helps to some extent, but when you turn up the volume to hear the person whispering, you also turn up any background hissing sounds, which makes it even harder to hear the original recording. The recording just has too much "noise."

The same thing happens in digital photography. If there isn't enough light to make a good picture (like not enough sound in a sound recording), the camera does its best to boost what light is available, just like turning up the volume of a whisper. But the same problem happens here, because doing this causes the picture to be filled with tiny, colored, grainy-looking specks. The specks are irrelevant or meaningless data captured by the camera when it "turned up the volume." This is noise in a photo, just like the background hissing sound of a bad sound recording. Just like the extra sound reduces the clarity of the sound recording, the extra light reduces the clarity of the photograph.

How can digital noise be stopped? By giving the camera enough light to begin with, so it doesn't have to amplify more than necessary. I explain ways to do this later on, in chapter 6.

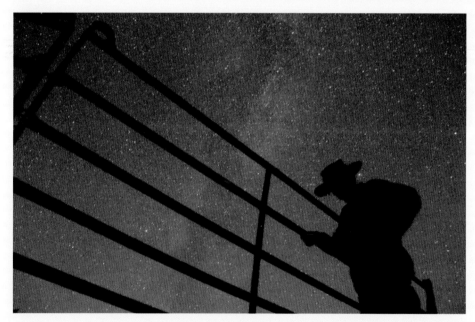

For this shot, I positioned the camera down low near the ground and pointed it up at the fence and the starry sky. Then I used the self-timer to trip the shutter so I could get into the photo as well. The result is a kind of "star silhouette" picture that I really like. The only problem with it is the excessive noise that is speckled all over the photo—a result of taking pictures in the dark and using a high ISO number, 1600. But I liked this idea enough to try it out even though I knew it would be noisy.

Sure, DSLRs are heavier and more expensive, but I feel that the advantages far outweigh the disadvantages. If you have a DSLR available to use now, then you're all set for some great photography. If you are considering the purchase of one, I would suggest looking at either the Nikon or Canon brand. Other brands exist, of course, but these are the two major manufacturers of this type of camera, and both companies have a long history of quality workmanship. Buy the best model you can afford.

My Pixels Are Better than Your Pixels

Some people pay a lot of attention to the number of megapixels a camera can deliver. One million pixels (dots) make up a single megapixel. The more pixels in your digital photo, the better the resolution and clarity. This might lead you to believe that the number of megapixels is the only thing that matters when choosing a new camera. While it *is* true that a 10- or 12-megapixel camera can give you more quality than a 7- or 8-megapixel camera, it's not the only thing that matters.

What you might not know is that sensor *size* also plays a valuable role in determining image quality. Let's say you are comparing two different cameras, a point-and-shoot model and a DSLR, both with 10-megapixel sensors. It seems likely that they would both give the same quality of image—but they don't because they have sensors of different sizes. The smaller point-and-shoot camera is going to have a smaller sensor, much smaller than the one on the DSLR. Because of this, those 10 megapixels have to be crammed together in a very small space. This makes for a lower-quality image than an image that has pixels spread out over a larger sensor and has more room to breathe.

I believe that anyone with a passion for photography should bypass the point-and-shoot route and buy a DSLR.

Cleaning Your Camera's Sensor

Have you ever noticed how radios, televisions, computers, and other electronic devices like to collect dust? It seems that no matter how often you clean them off, they always want to get dusty again. This is because of the static electricity that these kinds of devices produce, even when they're turned off. Unfortunately, your camera's sensor is the same way: It's an electronic device prone to attracting dust specks. Most of the time, however, no dust can reach your sensor because your lens blocks the way. But any time you change lenses, you run the risk of letting in a few bits of dust that might find their way deep into the camera and become settled on top of your camera's sensor. (Point-and-shoot cameras are pretty much immune to this problem because their lenses cannot come off, leaving the sensor hidden away all the time.) When these particles start to build up, you'll begin noticing small dots on every picture you take. You can tell it's a dust speck because it will appear in exactly the same spot in every photo. Depending on how bad the dust buildup is, this could be a very bad thing for your photography.

How can you avoid sensor dust? Some people suggest that you just stick with one type of lens and never change it. Their thinking is that if the lens never comes off, no dust can ever get in. The truth is that dust can *still* get in through the lens mount—even if the lens never comes off. Plus this strategy rather defeats the purpose of a DSLR. The whole idea is that you can

swap lenses depending on your situation and the type of image you are visualizing.

A better solution is to take precautions while changing lenses, such as practicing some of the following:

- **Avoid exchanging lenses in dusty environments.** If you're outside on a windy day, or near a gravel road, or standing in a construction zone, or some situation like that, you want to avoid removing your lens for any reason. If you can see dust floating in the air, some will almost certainly find its way into the camera.

- **Hold the camera upside down while changing lenses.** This is kind of awkward at first but easy enough to get the hang of. The idea is that if your camera's body is pointed down, it would be more difficult for dust to travel *upward* and into the camera. Be sure to wear the neck strap when doing this so that you don't inadvertently drop the camera.

- **Avoid *excessive* lens changes.** You wouldn't want to put on a lens, take one photo, change lenses, take another photo, and then change lenses again. This would be sure to attract dust. A normal amount of lens swapping is fine.

- **Always keep a lens or body cap on your camera.** This is probably obvious but worth mentioning just in case.

Cleaning dust from a DSLR's sensor is a delicate task that requires you to work carefully to ensure that you don't accidentally damage the sensor, bring new dust in, or smudge it. I would recommend getting help from someone knowledgeable the first few times you try it.

Okay, great, but what if there already is some dust on your sensor? Then what? If you check your camera's manual, it probably has a part in it that says something to the effect of "Never clean the sensor yourself! You can damage it!" And there is some truth to this. Sensors are very delicate electronic instruments and should always be treated with the utmost care. However, stating that you can never clean a little dust from the sensor yourself is excessive.

Of course, you can always just live with the dust specks in your pictures and clean them off later using your photo-editing software. Usually, photo-editing software has some kind of "spot removal" tool that can be used to clean away a misplaced dot or two. However, this is about as much fun as mowing the lawn with a pair of scissors and is not a very practical long-term option.

If you want to try cleaning the sensor yourself, first read your camera's manual and find out how to go about it. The manual will tell you how this is done, despite its repeated warnings about *not* doing it yourself. I would also recommend that you ask a more advanced photographer or someone at a photo store to help you with the cleaning the first few times, just to be sure you don't damage your camera.

Sensor cleaning requires that the DSLR's mirror be raised and held in an open position while the lens is removed, and it must remain open throughout the cleaning process. To do this, make sure that your camera's batteries are fresh. If the batteries were to go dead just while you were in the middle of cleaning the sensor, the mirror would slap shut, and you would no longer have a working camera.

There are all kinds of sensor cleaning products out there, from brushes to swabs to cloths, but I've had great results using the Dust-Aid Platinum. This is an easy-to-use

system and also a safe one, as long as you follow the directions carefully.

By the way, dust specks on the *outside* of your camera, like on the front of the lens, hardly ever cause problems like this. You should carefully clean the front of your lens occasionally, but only when it really needs it. Overcleaning the front of a lens can lead to scratching.

Batteries

Batteries are an important part of digital photography. No batteries, no photos. For this reason, you'll want to be quite careful not to have your batteries fail at the precise moment when you want to photograph something important. Some valuable tips:

- **Always have a spare set of batteries when you go out.** If your camera takes regular AA-type batteries, all you have to do is buy one of those super-packs of something like twelve or sixteen batteries, throw it in your camera bag, and march off to find great pictures. Simple. If your camera runs on a rechargeable battery, you will probably want to purchase an additional battery. This way you can always be using one and charging the other. Or, if you plan on going out for a full day and won't have any chance to charge, you can at least start off with two fully powered batteries.

- **Limit the use of the LCD when possible.** Your camera's LCD is a power hog. It eats up electricity faster than any other camera function, except maybe the flash. For this reason, turning off the LCD whenever you can will help save some of your battery power. If you're working with a point-and-shoot camera, you may have to use the LCD all the time when shooting, but you can still turn the

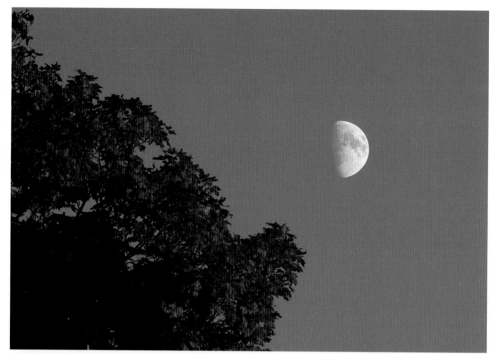

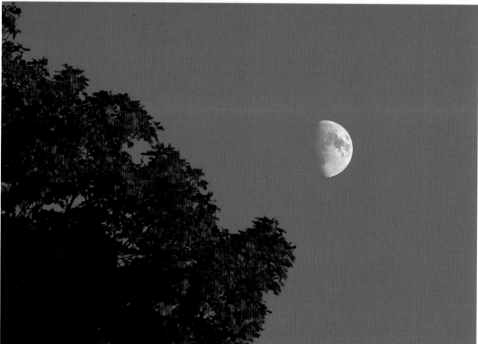

I was so excited when I saw this opportunity to photograph the moon next to a branch of autumn leaves. I took several pictures of the scene at various settings but was disappointed to find out later that these settings (my lens aperture of f/36) had caused the dust on my dirty sensor to appear all over the photo (*top*). I wasn't aware my sensor needed cleaning because the specks didn't show up under normal conditions. I was able to repair the image with photo-editing software (*bottom*), but it was quite time-consuming.

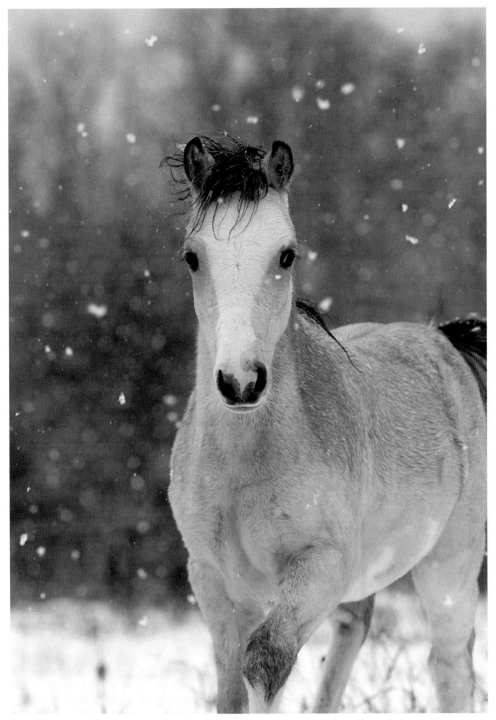

Cold conditions didn't stop my DSLR from creating some great photos during this heavy snowfall, but I was concerned about the wet flakes collecting on my camera's controls and lens. A small plastic shopping bag with a hole in the bottom did the trick. I poked my lens out through the hole and used the body of the bag to protect the rest of my camera from the snow.

camera off whenever possible and avoid using the playback feature whenever you can.

- **Try lithium batteries.** If your camera uses normal batteries (like AAs), you might want to try using lithium versions. Lithium batteries are lighter than alkaline, for one thing, plus they last *a lot* longer, especially in digital cameras. Unfortunately, they are correspondingly more expensive. If you do choose to try lithium batteries, be aware that they last and last but then will die abruptly, without warning, whereas alkaline batteries die slowly and can be coaxed along to keep running for a while even after they become weak.

Cold Weather, Hot Weather

Digital cameras can get fussy in difficult weather conditions, but not nearly as much as people say. As far as cold weather goes, probably the worst thing that could happen is that your batteries could get too cold to function properly. If this happens, you can usually swap the cold set of batteries for a warm pair and keep going. The cold set usually isn't dead and will return to full power after warming. (Keeping the extra batteries under your coat, close to your body, is always a good system.) Other than batteries becoming sluggish, I've rarely had any problems with camera malfunctions in cold weather. Typically, your camera is able to stay out far longer than you want to! When you do come back inside from the cold, you'll need to warm your camera up slowly to avoid condensation. You can place your camera inside a plastic bag (to halt condensation) and then bring it to a slightly warmer environment (like an unheated garage, perhaps) for a few minutes before bringing it back indoors. In *extremely* hot or cold temperatures (such as 90 degrees Fahrenheit or -20 degrees Fahrenheit), your camera's LCD screen might start acting weird, showing goofy colors or not working at all. This will go away once the camera returns to a normal temperature, but it's probably unlikely you'll be doing much photography in such conditions anyway!

Mama Took My Kodachrome Away!

This is a book devoted to digital photography, but I'm going to take a minute to mention the possibility of using a film camera for your photography. Here's why: The price of film cameras has dropped incredibly over the past several years because almost everyone wants to shoot digital. Pro-quality film camera bodies that once cost thousands of dollars have become available used (or even new) for prices in the range of only a few hundred dollars. What I'm saying is that it is now possible to obtain pro-quality equipment for sometimes *less* than an entry-level DSLR. Of course you are going to have film and processing costs, but you will have a chance to work with equipment of a caliber that is far higher than you might be able to obtain otherwise. (By the way, the film cameras I'm talking about here are known as just plain SLRs [Single Lens Reflex], without the D for "digital" on the front.)

THE BASICS OF GOOD PHOTOGRAPHY

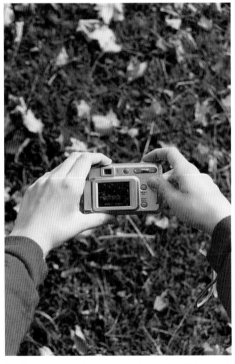

The best photographers take the time to familiarize themselves thoroughly with all of their cameras' controls so that they can take full advantage of any unique situations quickly, without stopping to search for a control or dial.

You've probably taken lots of pictures in the past, but how often did you actually slow down and ask yourself, "Just what am I taking a picture of? For what purpose? Why does it deserve to be photographed?"

There are lots of times when these questions don't matter—like during the holidays when you're snapping pictures of family members just for fun. In those cases, there's no reason to slow down and ask yourself these questions. You just want the shots! But when you're taking photographs for a more serious reason and trying to do the best job you can, you should stop and think things over before you run off and start snapping.

The world has no shortage of images. Almost everyone I know takes pictures for some reason, but hardly anyone slows down to take *good* pictures. Sometimes people don't care if their pictures are bad, or they don't care enough to learn how to do better. The point is that there are many pictures in the world to look at, and you need to make sure that your pictures are the best they can possibly be so that other people will want to look at and enjoy them.

What *Is* My Subject?

Most photographs are trying to show us something. There is some object, person, weather event, building, plant, animal, or other thing that we are supposed to look at. "Oh, it's a picture of George." "What a pretty barn!" "Wow, great clouds!" This thing (or things) that we are supposed to be identifying is the photograph's *subject*. The

> The subject is the most important part of the photo, and unless the photograph is an abstract image, the subject should be immediately recognizable.

subject is the most important part of the photo, and unless the photograph is an abstract image, the subject should be immediately recognizable. It should stand out in the photo, so that there is absolutely no doubt in the viewer's mind: *This is a picture of_____.*

Recognizing Your Focal Point

The "focal point" of an image is the term used to describe the most important part of the subject. In other words, the focal point is

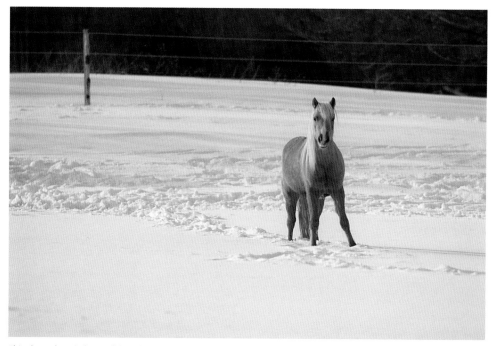

This photo doesn't show off the subject well. We know it's supposed to be a picture of a pony, but we see too many distracting elements: the fence, the trees, the background of tracks in the snow. These elements might help us to better understand the pony's environment, but in this case, there is not enough emphasis on the subject. We need to get closer.

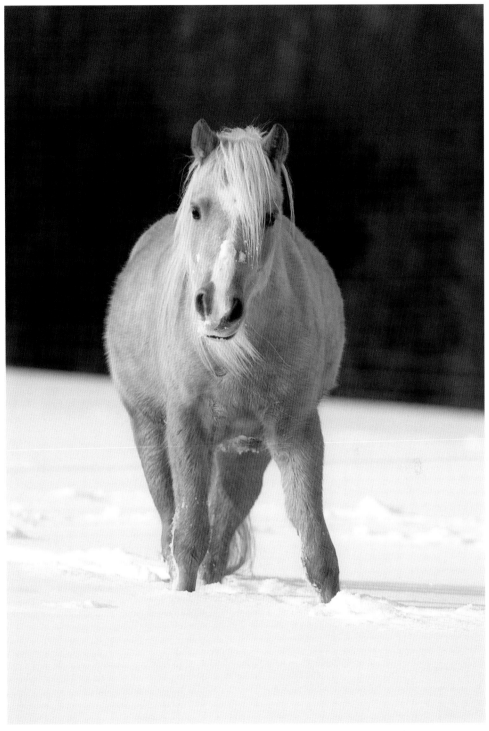

This is much better than the previous photo. By simply getting closer, I was able to focus the viewer's full attention on my subject. You can't help but notice her now! And yet, you can still see enough of her environment to get a feel for the cold, snowy conditions.

the most important part of the most important part. If the subject of a photograph is Aunt Barbara, then the focal point is Aunt Barbara's face. If the subject is a beautiful outdoor scene of a grassy meadow, the focal point might be a pretty apple tree alone in the middle of the field. If the subject is a football player running, the focal point could be the player's hands reaching to catch the ball.

Like the subject, the focal point should be immediately identifiable. It should be simply obvious to the viewer: *The most important part of this picture is* _____.

Get Close!

Unfortunately, many photographs fail in trying to convey their subjects to their viewers. One big problem that beginning photographers often have is that they don't get close enough to the subject. It happens constantly: People see something they want a picture of, grab a camera, take a shot, and that's it. They don't slow down to think about what they're doing, and they don't get close enough to emphasize the subject.

There are two ways of getting close. One is to actually walk closer to your subject; the other is to zoom in with your lens. You can also use both of these solutions at the same time: walk closer *and* zoom in.

Getting close can help the viewer identify your subject more easily. If there is nothing else in the photo but your subject, your viewer will have little doubt about who or what the subject is. This is so simple and so easy but so often overlooked. In my opinion, getting in close to your subject is

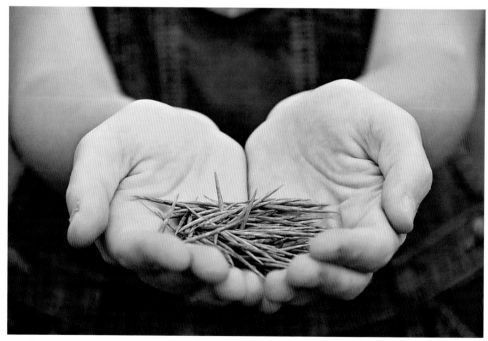

This photo is of a little girl's hands holding a variety of grass seeds, but the seeds are the focal point (most important part). Therefore, I made sure to focus clearly on the seeds while allowing the girl's hands (not so important) to fall out of focus slightly. The tips of her fingers are not as sharp as the seeds, but this is all right because we're supposed to notice the seeds mostly. Also, I came in very close with my camera for this shot to avoid including anything that wasn't directly associated with the picture I had in mind. The blue background of her overalls makes a nice backdrop.

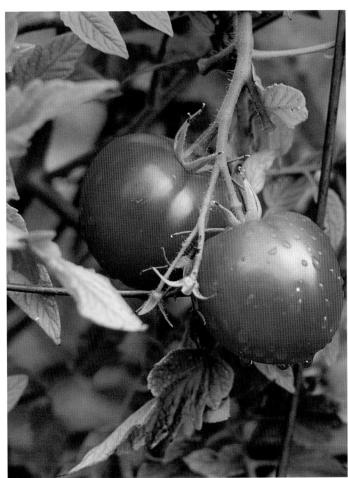

Rather than taking a picture of the entire plant, which would have confused the viewer, I chose to come in very close to these tomatoes. Doing this put more emphasis on them. A very simple background of green leaves contrasts nicely against the red tomatoes.

one of the most important things you can do to improve your photography.

On the other hand, don't get *too* close! Being too close to your subject (particularly people and animals) can create distorted, unflattering photos. Your camera also might not be able to focus when you stand too close to your subject, so doing this might result in blurry pictures.

Choosing the Correct Focal Length

The type of lens you use has a very big influence on your photos. Some lenses are very "wide," meaning they show a large area around the photographer. Other lenses offer a mid-range view, while still others can behave like a small telescope, making far-away objects appear close. These differences of perspective are determined by how long the lens is or, as photographers say, what its *focal length* is. This choice of focal length is entirely up to the photographer; no camera can make the decision for you.

Lenses can be divided into two basic categories:

- **Zoom lenses:** Zoom lenses are lenses that move in and out to create different perspectives. Almost all point-and-shoot cameras have a zoom lens built

into them. The photographer then uses a control on the back of the camera to zoom in and out as desired (known as power-zoom). Zoom lenses are also popular for DSLRs, but in this case the photographer manually turns a ring on the lens (the "zoom ring") to set the focal length.

- **Fixed-focal-length lenses, or "prime" lenses:** This kind of lens only offers one perspective, but it usually performs extremely well; sometimes better than a zoom lens set to the same focal length. Prime lenses are popular with some professional photographers.

A standard film camera uses 35mm-format film, which means the actual film that captures the image measures 35 millimeters across. Although digital cameras of course don't use film, they are commonly described in terms of the *35mm-format*

equivalent when discussing focal lengths. The lenses on point-and-shoot digital cameras are usually very small, while lenses attached to larger DSLR cameras are usually bigger. To keep things simple, camera designers often describe lenses of all sizes in terms of the 35mm equivalent—a little mathematical conversion that is used to make sure everyone is using the same terms to describe a lens, regardless of camera or sensor size. If you own a point-and-shoot camera, the lens or manual probably tells what your 35mm equivalent is (as in "35mm equivalent: 35–105mm"). If you own a DSLR, the manual will tell you how to convert the focal length of your lenses into 35mm equivalent. (The equation is often the focal length times 1.5).

Here's a quick look at some common focal lengths and what they do best:

- **28mm and lower:** Wide, wide, wide. The lens takes in a huge view of the

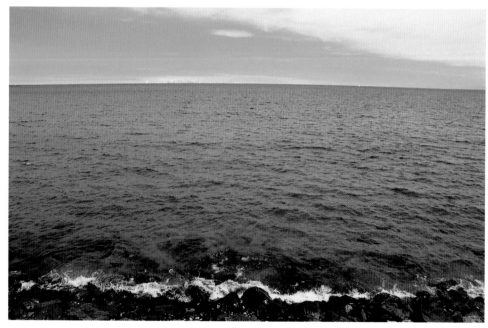

This photo of Lake Superior was taken with a 28mm focal length. Notice how the wide-angle view causes some distortion on the horizon line; it bends upward near the middle and falls off toward the sides. If you want to avoid this look, don't photograph long, straight lines with a lens this wide.

area, useful for sweeping landscape images. Distortion (when objects in the picture become bent-looking or larger or smaller than they really are) can occur when using a wide focal length like this.

- **35mm:** Still wide, but a little more confined and with considerably less distortion than a super-wide-angle lens. Very popular.
- **50mm:** This focal length is sometimes called a "normal" lens because it supposedly represents the same magnification that our own eyes perform naturally. Personally, I've always found 70mm to be closer to this "normal" range. A 50mm lens is considered to be a classic focal length, and many pros prefer it over any other. However, I've always found it to be pretty dull.

- **70mm:** What I consider a "normal" lens.
- **80mm:** Starting to magnify things a little bit. An 80mm lens is nice for most people portraits.
- **100mm:** A short telephoto with some magnification, 100mm is my favorite focal length, and it's great for people and animals.
- **150mm:** Considerable magnification.
- **200mm:** A mid-range telephoto, and my second-favorite focal length.
- **300mm and higher:** Super telephoto. Extremely high magnification, able to bring far-away objects much closer. It's also very expensive.

Of course, it is possible to set a zoom lens at focal lengths that are in between these listed here, like 46mm, for example, or 72mm.

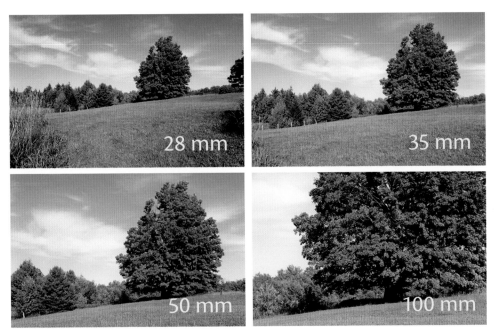

Here are four pictures of the same scene, photographed at four different focal lengths. Personally, I like the 35mm and 50mm views the best. The 28mm view seems a bit wide and takes in too much of the scene. The 100mm view seems too tight and doesn't show us enough of what we're looking at. If I had to pick the best of these four, I would go with the 50mm.

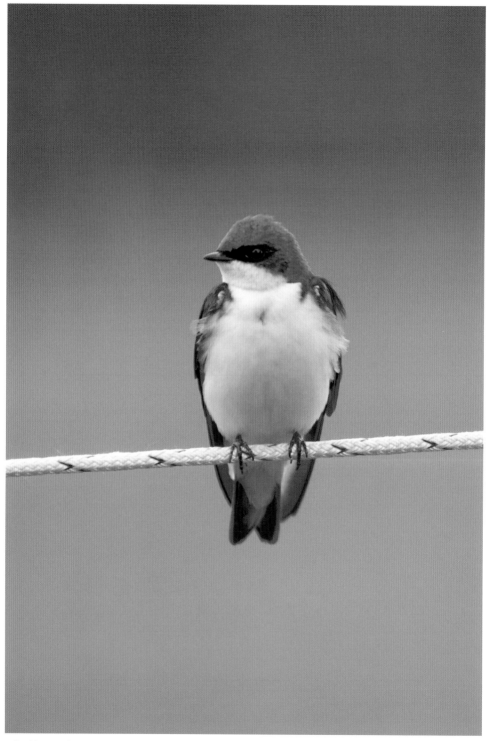

A focal length of 300mm was used to get a very up-close view of this bird without startling it away. Notice how there is no detail in the background; the long focal length has blurred it all away.

Using the Viewfinder

Your camera's viewfinder is a useful piece of equipment. Without it, photography would be a hit-and-miss affair. Viewfinders let us see what we are aiming at, how the focal length is affecting the subject, and if the subject is in good focus. Depending on the camera model, there may be even more information available in your viewfinder, including various settings for more advanced photographers. However, no matter what information is included in your viewfinder, you want to make sure you are using it properly. This means:

- **No sloppiness.** Don't just bring the viewfinder to your eye and glance through it in a cursory manner. Bring the camera up straight to your eye and keep your eye close enough so that you can see the whole frame at once. You want to be able to see all four edges all the time, so that you don't either A) cut off something important without seeing it or B) *include* something unimportant without seeing it. If you wear glasses, it may be difficult to achieve this, so try photographing without your glasses for a time and see if you can work that way and still see clearly enough to function.

- **Keep it straight.** Surprisingly, this can be harder than you think. Even people who have been taking pictures for a long time (like me) can still be caught off guard and take a crooked picture. So take the time, if possible, to check that you are holding the camera level before snapping the shot. Sometimes a small amount of tilt can be repaired with photo-editing software, but you usually have to crop off a bit of the photo around the edges to do this, often losing some important detail in the process.

- **Keep both eyes open!** People sometimes think that they need to close the eye that isn't looking through the viewfinder. So they peer through with one eye and squint up the other. This is very uncomfortable and totally unnecessary. In fact, it's worse than unnecessary because holding one eye shut can throw off your ability to keep the other eye looking fully through the viewfinder. Instead, keep both eyes open *but only concentrate on what you're seeing through the viewfinder*. This is much easier than it might seem at first and has the additional advantage of allowing you to keep an eye on what potential photo opportunities are happening outside the viewfinder. Usually, the only time I close the other eye is if I'm making some very critical changes to the focusing or composition. Also, make sure to keep your right eye looking through the viewfinder, not your left. Cameras are designed to be used with the photographer's right eye.

> Being able to achieve sharp pictures is one of the most important aspects of photography. You can have a photograph that is otherwise interesting and attractive, but if it is even slightly blurry, it will fail as a photograph.

Sharp, Sharp, Sharp!

Being able to achieve sharp pictures is one of the most important aspects of photography. You can have a photograph that is otherwise interesting and attractive, but if it is even slightly blurry, it will fail as a

photograph. Unfortunately, blurry pictures are one of the most common mistakes that beginning photographers make. How can you avoid this common pitfall? Let's take a look at some solutions.

Autofocus

At first, you might think autofocusing sounds like a perfect solution. All we have to do is concentrate on our subject and the camera will make sure everything is sharp, right? Sometimes, yes. But often there are problems that crop up. This is because autofocusing is one of the most misunderstood aspects of photography. It's misunderstood because of the key word "auto." Auto makes us think that there is no user input required, and this just isn't the case.

Autofocusing on a digital camera is not like that on a video camera. On a video camera, it truly is automatic—you turn on the camera and it focuses all by itself, all the time, no matter where you aim the lens. On a digital camera, you have to *tell* the system to perform autofocusing first, before the actual photo is taken. You probably already know how to do this: You push the shutter button down halfway to focus and then

down all the way to take the picture. Inside the camera's viewfinder or on the LCD screen you will find one or more points, called *focusing points*. The camera attempts to focus on whatever object or person happens to be on the active focusing point at the time you press the button down halfway. (As we'll see in chapter 3, the location of the focusing point or points can cause some problems when it comes to arranging attractive photos, but we won't worry about that for now.)

When you press the shutter button down halfway, the camera will attempt to focus properly. Whether or not the camera is successful in doing this depends on a few things. If you are working in particularly dim lighting, the camera may not be able to "see" well enough to focus properly. Or, if you're working with a shiny subject or a subject that is entirely one color, the camera may not be able to tell exactly where to focus. The same goes for objects situated behind other objects, such as a horse behind a fence. The camera may want to make the fence sharp but not the horse. In these cases, you will need to bypass the camera's autofocusing system and use manual focusing.

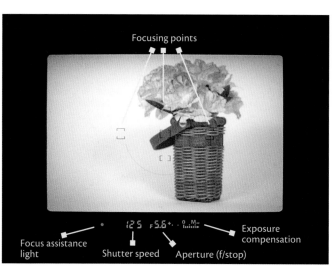

Here's a look at the inside of a DSLR's optical viewfinder. Every camera model will be slightly different, but the items shown here will almost certainly be included in whatever DSLR you use.

Focusing points

Focus assistance light

Shutter speed

Aperture (f/stop)

Exposure compensation

Your camera's LCD screen can be helpful in checking the sharpness of your pictures. Go to playback mode and then zoom in on an image to view a small portion at high magnification. This makes it easy to see if you are getting sharp pictures. You can do this right after you take a picture, and if the photo isn't as sharp as you'd like, you can try again. *Shutterstock*

Manual Focusing

Just about every camera can be focused manually, but let me say right now that you probably shouldn't even waste your time trying to manually focus a point-and-shoot camera. Doing so usually involves accessing some kind of "manual focus" menu and then telling the camera exactly how far away to focus . . . *way* too much trouble. I'd rather fuss with a rambunctious autofocus than do that.

However, if you own a DSLR, manual focusing isn't very difficult to initiate. All that is involved is switching your camera to the manual focus setting (usually a simple switch on the camera body or lens) and turning the front lens element to the left or right until the viewfinder looks sharp. Doing this quickly and accurately takes a lot of practice, but (depending on the camera and situation) you can sometimes get more accurate results this way than with autofocusing.

∞
Quick Tip:
To Infinity and Beyond

You may notice this symbol painted on your lens, near the glass: ∞ . It stands for "infinity," which means, essentially, limitless. If you manually focus your lens all the way to this symbol, the lens is then set to focus as far away as possible. This setting is useful in various situations but particularly if you take pictures at night of the stars or moon. Your camera's autofocusing probably won't be able to function when it's this dark, so this is a nifty solution.

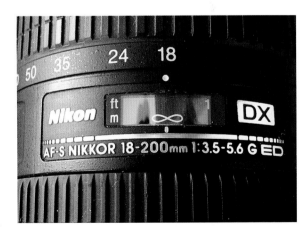

Beep!

No matter which focusing method you use, either auto or manual, the camera may give you some clues to help you know when your subject is perfectly sharp. Some cameras will make a beeping noise, and others may flash some kind of light in the viewfinder. These hints can be helpful, but the biggest clue that your image is sharp may simply be that it looks sharp in the viewfinder. Use whatever system works best for you. (By the way, if the autofocusing beep begins to annoy you, it can be turned off; check your manual.)

Camera Shake

In addition to focusing properly, getting a sharp image also requires that the camera be kept reasonably still during the exposure. Otherwise, you end up with a picture that is blurry because of another reason: camera shake. Just how still the camera has to be kept depends on the lighting conditions. Generally speaking, photographs taken in dim conditions require that the camera

be kept steadier than a picture taken on a bright, sunny day. But no matter what your lighting conditions, sharper pictures will always be possible if the camera is kept steady.

The way you hold your camera can have a big effect on how steady you are able to keep it. For best results, always hold the camera with both hands, with your right hand supporting the camera's right side and your left hand supporting the camera from underneath. On small point-and-shoot cameras, be careful not to let your the fingers cover up the lens or flash. Keep your right index finger resting on the shutter button but not pushing on it. Try not to grip your camera; hold it in a relaxed but steady way. If you are using a DSLR with an optical viewfinder, it can be helpful to brace the camera gently against your face (but only very softly). Contrary to what you might think, it's actually easier to keep a heavier camera steady than a lighter one, so DSLRs have a slight advantage in this way. Try to

You're Lagging Behind!

Ron's camera is driving him crazy. Every time there is a fantastic photo opportunity, he aims his camera and clicks and . . . nothing happens. By the time the camera actually gets around to taking the picture, the perfect moment is gone, and the nice smile or shaft of gorgeous light has vanished. This effect is commonly known as *shutter lag*, but it's not entirely the shutter's fault. Most of the problem happens because the camera is trying to perform autofocusing first (and perhaps trying to charge its flash as well), before allowing the shutter to open. This can be extremely aggravating.

It is also somewhat avoidable. First of all, don't just jam down the shutter button without warning and expect a good picture to happen. You need to smoothly and softly press the shutter button halfway and wait, poised—ready to take the picture, but paused. This gives the camera time to prepare for the image, and it gives you time to anticipate the perfect moment. Maybe you're waiting for just the right expression on someone's face during a portrait. Maybe you're waiting for the peak of action at a sporting event. Maybe you're waiting for a dog to catch a Frisbee. Whatever the photo, you will always have better luck if you press the shutter button halfway and wait. Press the shutter button down all the way only when everything is perfect. And when that perfect moment does come, you and your camera are ready to perform.

This photographer is using a good technique for holding his DSLR camera. The right hand supports the right side of the camera and controls the dials and the shutter button, while the left hand supports the camera and lens from below and controls the zoom ring.

brace your arms against your body as well, this offers the camera even more support. The key is to stay relaxed but steady. For very particular shots in dim conditions, where it might be difficult to keep the camera steady without blurring the picture, try taking in a deep breath and holding it just before you snap the photo. This sometimes helps you gain a little bit more steadiness.

The focal length of your lens has a huge effect on camera shake. If you've ever worked with a video camera, you've probably seen why: At wider focal lengths ("zoomed out") it's easy to keep the camera steady. But at longer focal lengths ("zoomed in") it becomes more and more difficult to hold the camera steady enough to shoot a clear picture. This is because long focal lengths magnify everything—including your hand movements. Wide-angle lenses like 28mm through 50mm are the easiest to hold steady; telephoto lenses like 100mm through 200mm are harder. Anything over 200mm should probably be put on a tripod, or camera shake may become impossible to avoid.

Tripods

A tripod anchors your camera on three solid legs, taking away any chance of camera shake. For this reason, professional photographers like to use tripods whenever possible, in order to create the sharpest photographs they can. Tripods also allow unique photos to be taken, such as those at night when the camera must be kept perfectly still for long periods of time.

A huge variety of tripods are available, in an equally huge variety of prices. Without going into a long description of all the types, let me suggest that you stay away from very cheap tripods and any made with plastic legs. These kinds are usually worse than worthless because they are so flimsy they

39

can tip or blow over without any warning, taking your camera with them. There are many good kinds of tripods made out of lightweight metal that are sturdy, reasonably light, and economical.

When using a tripod, you want to make sure that you have all three legs locked in a secure position and that the camera is properly connected to the tripod. Also, make sure the camera is secured in a level position before shooting. It's really easy to take a crooked picture with a tripod.

Image Stabilization

Image stabilization (also referred to as *vibration reduction* or *optical stabilization*) is a way to reduce camera shake without the use of a tripod. There are two different kinds of image stabilization:

- **Optical image stabilization** is the better option of the two. With this method, the lens (or camera sensor) can "feel" your hand movements and adjust itself to counter the vibrations. There is usually a switch on the camera or lens that turns on this feature. Optical image stabilization will always give you sharper pictures, regardless of your photographic conditions, and takes nothing away from the quality of the image. For this reason, I recommended leaving it on at all times. Many people disagree, stating that on a bright, sunny day using a fast shutter speed, image stabilization does not help. However, the fact is that optical image stabilization will always help make sharp pictures even sharper by reducing camera shake in all situations.

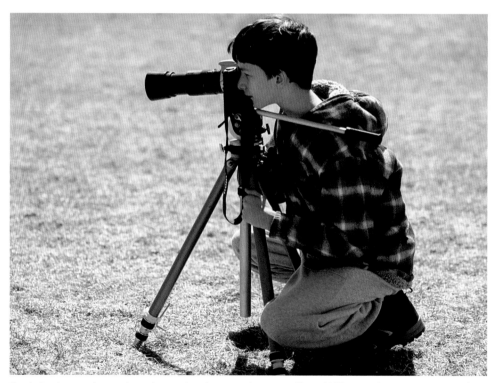

Good tripods can make very sharp pictures, since the camera is supported by a rigid frame and not your comparatively unsteady hands. Some photographers really like to use tripods and employ them whenever possible, while others feel that they discourage creativity. I suggest you try using a tripod for a while and see how you like it.

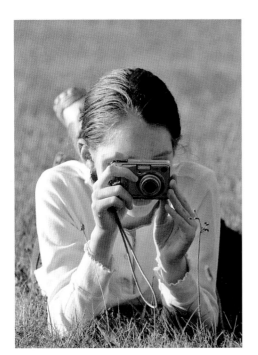

If you are photographing down close to the ground, it can be helpful to use your arms and elbows as a brace against the ground to help support your camera and keep it steady.

- **Digital image stabilization** (also known as *Electronic Image Stabilization* or EIS) is not as good an option as optical. For this method, the camera reduces the quality of your photo slightly so that it can digitally do what optical stabilization does by itself: cancel out your hand movements. Because it reduces the quality of your image, I would recommend using it only in conditions where you truly need help holding the photo, either in dim conditions or when trying to hold up a lens with a longer focal length.

Exposure Compensation

We use the word "exposure" when talking about the amount of light that reaches the digital sensor. If too much light is let into the camera, the image will be *overexposed*.

It will appear pale and whitish, and bright areas of the photo may be burned out (containing no detail). Likewise, if not enough light reaches the sensor, the image will be *underexposed*. The entire photo will be too dark, with no details in the shadows. A correct exposure makes the scene appear normal, just as you saw it when you were there or, in some cases, how you wished it would have appeared.

With the exception of manual mode, all of the exposure modes described above assume one thing: that the camera is going to make the right decision regarding your photograph's exposure. Usually the camera *is* correct. Usually the choice it makes in determining just how much light should reach the sensor is correct, and the resulting photo is quite pleasing. But sometimes the camera gets it wrong—or, more specifically, the camera's *light meter* gets it wrong. The light meter isn't a genius; the best it can do is look at a scene and try to average things out. A light meter might look at a scene of a big field of grass with blue sky and say, "Well, that sky is really bright, so I don't want to let in too much light. On the other hand, that grass is a fairly average tone. I don't want to lose detail in the grass. I'll just average them out and let in enough light to make them both acceptable."

Like I said, this almost always works, but occasionally the light meter gets it wrong and puts too much emphasis on making the sky exactly right, at the expense of the grass below. There are other times in which the light meter can be fooled, such as in very bright or very dark conditions. Imagine wanting to take a photograph of Aunt Barbara standing outdoors on a snowy afternoon. With the exception of Aunt Barbara herself, the entire picture is white. The light meter sees all this brightness and

Exposure: A Mass of Modes

Cameras usually have a series of modes, called exposure modes, which allow you to have some control over how the camera performs in various situations. These modes are accessible by some kind of dial, menu, or other method. Your camera may have only some of these modes, or it may have all of them. Here's the lowdown on the basics of each exposure mode.

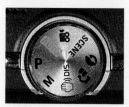 **Auto:** Auto exposure mode is usually represented by something green; a green box or a green word that says, "AUTO." In this mode, the camera handles everything and you have little control.

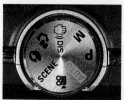 **Program mode:** Program mode is almost always represented by the letter *P*. Program mode is one step away from fully automatic. The camera still retains most of the control over your picture, but you are allowed to make some changes to shutter speed and aperture, if you understand these settings and know what you are doing (see chapter 6).

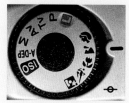 **Portrait mode:** Portrait mode is usually represented by a little picture of a person's head. In this mode, the camera puts emphasis on making your subject—presumably a person's face—very sharp, while attempting to throw the background out of focus. Just how well the camera is able to achieve this depends a lot on what lens you are using and how large the camera's sensor is, but usually portrait mode does a nice job. Cameras that have larger sensors—like DSLRs—perform better in portrait mode than point-and-shoot cameras. Portrait mode also adjusts some color and tone settings to make the subject's skin tones look as nice as possible.

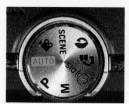 **Landscape mode:** The icon for landscape mode is usually a picture of some humps that are supposed to be mountains. Landscape mode is the opposite of portrait mode. Instead of a nice, sharp subject with a blurry background, landscape mode tries to make *everything* in the photo look sharp, from that tree in the foreground to that mountain in the distance. The smaller the sensor, the better the camera can achieve this objective. For this reason, point-and-shoot cameras tend to do a great job at landscape mode, performing far better at this mode than they do in portrait mode.

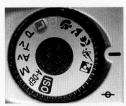 **Sports mode:** Sports mode is often represented by a picture of a stick figure skiing or running. Have you ever tried to take a photo of something moving, only to have the subject come out appearing as a blurry streak? Sometimes this effect is desirable because it can convey a sense of motion to the viewer, but most of the time we want moving objects to be sharp so we can see what they're doing. Sports mode attempts to achieve this feat by raising your camera's shutter speed as high as possible for the available light. Sports mode also sets your camera's autofocus to be more responsive in tracking moving objects.

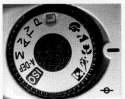 **Macro mode:** Macro mode is usually represented by a flower icon. In photography, a macro lens is one that is capable of producing close-up images, like photos of an insect, flower, or other small object. On a point-and-shoot camera, macro mode tells the lens to permit focusing on very close objects (usually this feature is disabled to allow the lens to autofocus more quickly on routine subjects). Some point-and-shoot cameras are pretty good at functioning in macro mode, and you can achieve some nice close-up photographs this way. On a DSLR, the camera has no control over how close a lens can focus; that ability is built into the lens (most lenses have a "closest focusing distance" printed somewhere on them). However, some DSLRs still offer this function, and it does . . . precisely nothing.

I have yet to understand exactly why camera manufacturers put macro modes on DSLRs.

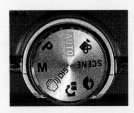 **Manual mode:** Manual mode is the exact opposite of AUTO and is usually symbolized by a big letter *M*. Manual mode puts the power of the camera's exposure in your hands, giving you full control over everything. It's by far the most difficult mode to use. There are times when manual can give you precise control in a situation, but often automatic does the job just fine.

Others: There are two other exposure modes your camera may offer, Aperture Priority and Shutter Priority. These are discussed in chapter 6.

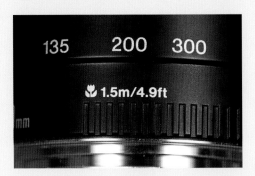

Check your lens' closest focusing distance, usually printed somewhere on the bottom of the lens. This is the closest that you and the camera can be to something and still be able to focus on it without blurring. This lens says it can focus as close as 4.9 feet.

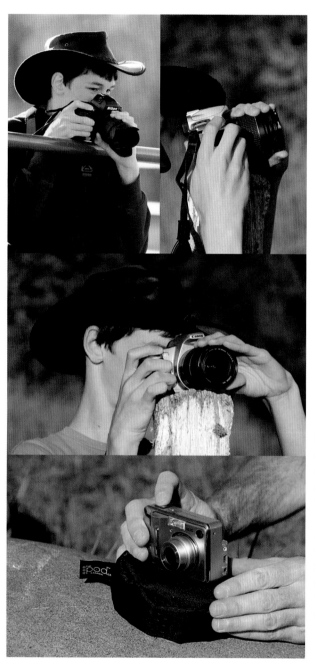

Tripod Alternatives

I use all kinds of things for tripods. Hats, camera bags, rocks, railings, my elbows, and the ground. It's not that I'm lazy and don't want to haul one around, I just sometimes get myself into situations where using a tripod is too annoying, too bulky, or too rigid. I like to move around and get my camera into great new positions where cameras haven't been before. Sometimes a tripod is just too big to do this, so I try using other things.

A big rock can make a great tripod if you can find one handy, but they're usually too slippery and can't hold the camera in just the position you want, so I always cushion the camera with my hat or a jacket or something. Camera bags work well for this too, and they can get you down low; just prop the camera on top and shoot. Another solution is a product called "The Pod," which is available in various colors (such as "The Red Pod") and is a kind of beanbag cushion with a tripod screw-mount built into the top. Very clever.

And remember, *you* make a pretty good tripod. If you're working down low, use your arms and elbows as tripods, bracing yourself against the ground and increasing your handheld stabilization that way.

Snow Days

Light meters have a hard time with snow; they sometimes want to make white snow look gray. I've found that when shooting wide-angle winter scenes, it helps to set exposure compensation to +1 and leave it there. However, if you are taking a picture of a subject in the snow and the subject takes up most of the image (with only a little snow showing around the edges), the camera will probably get the exposure correct without help. Only use the +1 setting if snow is dominant throughout the photo. And remember to put the exposure compensation back to 0 when you're finished shooting!

says, "Whoa! That's a lot of light. Can't let very much in. I might overexpose the sensor." So the light meter tells the camera not to let in very much light. The camera obeys, and the resulting picture is Aunt Barbara's very dark shape surrounded by gray snow, nothing like how the scene really appeared. The light meter was fooled. The same thing can happen in reverse if the scene is overwhelmingly dark; the light meter tries to make things too light.

A great solution to this problem is to use exposure compensation to lighten or darken a scene. Let's say you take a photograph, check it on the LCD, and immediately see

that something is wrong. Exposure compensation can work to fix this by offering you a little chart that looks like this:

-2	-1	0	+1	+2

Zero represents what the camera thinks is the correct exposure. If your photos are coming out a little too dark, you need to add more light, so you should select +1. If your scene is more than a little too dark, select +2 to add even more light. On the other hand, if your photos are looking too bright, you should select -1 or -2; this gives the camera less light. Make your adjustments and then re-shoot the photo with the changes.

In photography terms, each step on the line, from -2 to -1 to 0 to +1 to +2, is known as a *stop*. A photographer might say, "The scene was coming out a little too dark, so I increased the exposure by one stop." This could mean he went to exposure compensation and set the graph to +1. Some cameras refer to stops as exposure values, or EVs, but the word "stop" is a more traditional photography term. On some cameras it is possible to select half-stops, such as + $1\frac{1}{2}$, but I find that this much precise control is not usually needed. On a DSLR, exposure compensation can usually be accessed by buttons on the camera's body; on point-and-shoots, you will probably have to access a menu.

Of course you can always work on the exposure of an image later, when it's on the computer, and do almost the same thing, but the results will never be as good as if you had made the correct exposure in the first place. For one thing, trying to brighten a dark image on the computer will lead to excessive noise and graininess. And trying to darken an overexposed image may be impossible. It's always better to get exposure correct at the time you take the picture.

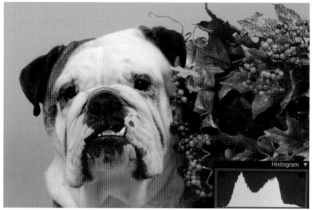

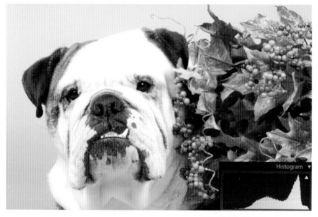

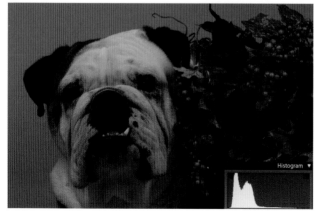

Histograms

A histogram is a little graph that your camera (or photo software) uses to measure the overall brightness of an image. Your camera's LCD screen may or may not be able to display histograms, although most DSLRs do, as well as some higher-end point-and-shoots. Check your manual: The histogram is usually accessed through some kind of menu or button combination; it is rarely a feature that is immediately accessible.

Reading a histogram is easy. You have a big hump of data inside the graph. If most of the humps are near the left side, the image is probably too dark. If most of the humps are over toward the right, it's probably too light. The photo should be taken again, this time using exposure compensation to combat the problem. Remember that the histogram is only a guide. There are some images that are exposed perfectly but appear wrong to a histogram.

CREATING BEAUTIFUL PICTURES

B y now you should have a basic understanding of the steps it takes to create technically correct photographs. You've learned how to take photographs of specific subjects that are sharp and well exposed. However, a sharp and well-exposed photograph is not necessarily interesting. I've studied thousands of photographs and have seen many technically perfect images that are, for lack of a better word, boring. This is the first of a few chapters that will help you truly become a photographer and not just another person taking dull and uninteresting images. This chapter will help to make sure that you are producing images that are not only technically correct but also engaging, exciting, and beautiful.

I saw these two horses grazing on a hill by the side of the road and stopped to grab a few shots, even though I couldn't get very close. So I tried to create a photo that suggests a feeling of space and distance by placing the horses far down at the bottom of the frame and filling up the top half of the photo with the interesting cloud patterns.

Working a Scene

There is one important difference between serious photographers and amateurs who simply take pictures. Serious photographers shoot a lot of images. Many, many images. After they have shot numerous images, they move around a little bit, find a new perspective, and take several more photos. Amateur photographers simply see something they wish to photograph, aim, shoot one photo, and move on. Sometimes the result is a good picture. Sometimes that first attempt is the best angle, and the person lucks out and takes home a winning image, but that is not usually the case. The process of obtaining the best possible photo of a particular scene or object requires work, observation, and many exposures. Photographers call it *working a scene*.

One way to work is to take one or two "just in case" shots once you've determined a worthwhile scene, much like the amateur I just described. These are to make sure that you actually have a nice overview image, something sharp and well exposed (and probably dull but that's okay for now) so that in case none of your subsequent images turn out, you won't walk away without something to show for your efforts. Don't experiment at this point; just shoot.

Once you've secured these images, you can start getting creative. Move around your subject. Make a complete circle. See where your light is coming from. Is the sun hitting nicely from the side? Are those shadows in the background going to be too dark? Should you get down for a lower viewpoint to eliminate the distracting building from the background? Continue to take pictures during this process.

Some professional photographers don't do this. They first examine the entire scene,

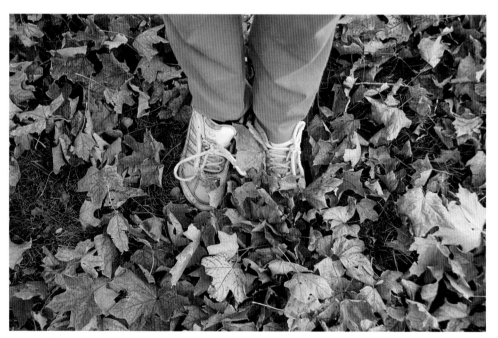

I was out taking pictures of children playing in the fall leaves when I noticed this interesting and unusual composition. All of the scattered leaves seem to gather around the girl's shoes and draw our eyes to them. I took a lot of pictures that day, but this is my favorite. I wouldn't have ever found this shot if I hadn't been thinking about working all areas and angles of the scene.

choose the best viewpoint, and snap only one image. However, these are often photographers who shoot with large- or medium-format cameras and can't afford the time it takes to set up and take down their heavy equipment over and over. Since you likely won't have this problem, you can take as much time and shoot as many photographs as you need to work your scene.

Finding Good Backgrounds

Beginning photographers often have trouble with backgrounds. This is usually because they aren't thinking about the backgrounds of their pictures. They don't think about them because their minds don't even register seeing them. Let's say that Ron wants to take a picture of Aunt Barbara and Uncle Dick during their holiday visit. In the back of his mind, he remembers once hearing that he should pay attention to his background, but all of his attention is focused on his aunt and uncle during the actual process of photographing them. This is good to a point. It's always important to know what your subject is and give it first priority. However, by not paying any attention to the background of his image, Ron runs the risk of creating a photo that actually distracts from his subject. Ron takes a picture, fails to notice the fence

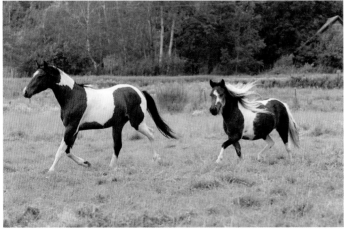

Both of these pictures show the same two horses in basically the same positions, but the lower photo is far superior to the top photo. In the first picture, there are too many distracting items (such as the fence, gate, and sheep). But I was able to take a much better picture by waiting a few seconds longer, after the horses had moved into a less distracting background.

(or the pile of magazines, used car lot, tree, or toys in the yard), and ends up with a picture of his aunt and uncle surrounded by various items that compete for the viewer's attention. Ignoring the background in favor of your subject is ultimately the same as ignoring your subject.

How can you avoid this issue? Once you've framed your image and you're ready to shoot, take a quick glance around the viewfinder. Examine all the sides. Is there anything that might be distracting? If there is, you should move. Any object that is not directly associated with your subject should be avoided. The object doesn't even

have to be ugly. There could be a beautiful birdbath sitting in a garden, but if you are taking a picture of some white roses, the birdbath might be a distraction. Moving a couple of feet to the left or right is usually enough to accomplish the goal. You can possibly move your subject or the offending background objects. (This is never my first choice because of the effort involved. I would almost always rather squirm into some other position to avoid an unnecessary object.) If there is still too much clutter, try a completely different location. It's usually easier to find a good background than it is to avoid a bad one.

Blurring the Background

There is one easy way to eliminate a busy background and create a pleasing, simple one—without moving! It sounds great, but there's a catch. You have to use a lens that is capable of this trick.

Later on in this book, I'll explain the use of *aperture*, which is the adjustable hole in any lens that controls the amount of light entering the camera. Light control is the main use of an aperture, but a wonderfully creative side effect is the aperture's ability to blur out a distracting background while keeping the main subject sharp and clear. If you study pictures in books or magazines, you will see that photographers constantly use this effect. Unfortunately, many point-and-shoot digital cameras are not able to produce a blurred background, and if you're using this type of camera, you may not be able to copy this type of blurred-background image perfectly.

For those using a DSLR camera, try using your camera's "portrait" mode, if it has one, even if the picture you want is not a portrait. This will tell the camera to do whatever it can to make the background fuzzy while keeping the subject sharp. A longer focal length will also help blur the background. Moving closer to your subject will also increase background blur. Using all of these methods together will draw the viewer's attention to the image's focal point and away from distracting backgrounds.

This is especially true when you're shooting outdoors. Whether you're shooting inside or out, you need to try to find a background that's free of clutter.

Finding New Angles

Exploring new angles is an important part of working a scene. Many beginning photographers limit themselves by shooting at eye level almost all of the time. While this works fine for some subjects, it's usually a boring way to shoot. Here are some ideas to try.

Get down to the subject's eye level

This is my favorite angle. I take many of my photographs from a sitting or kneeling position. It helps enormously with all kinds of subjects: horses, dogs, kids, babies, fences, and wildlife. If you're photographing something really close to the ground, like a rabbit, frog, or flower, then you need to get

> **Ignoring the background in favor of your subject is ultimately the same as ignoring your subject.**

yourself and your camera down even lower. This is important. The camera needs to be at the same level as the subject's eyes. In the case of a plant or nonliving thing, you want to be at the same level as the highest point of that object. It makes a dramatic difference when you get down and shoot at an even level with your subject instead of standing up and looking down at it. Your pictures will improve incredibly, and people will start to say, "Wow, how did you do this? This is a great picture." Even if other people don't know what you did to achieve the effect, they will be able to see the difference in your improved photography skills.

I had to kneel down very low with the camera to take pictures of this Yorkshire terrier dog. She is a very small animal, and I wanted to make sure that the camera's view was even with hers.

Get down really low and shoot upward

Getting the camera to a position lower than the subject and shooting upward is very tricky, a little goofy, and tons of fun. It can be an exciting angle for flowers, buildings, silhouettes, and other subjects. Not many people put their heads close to the ground to look *up* at a flower and see things from this perspective, so the reactions to images taken in this way can be very rewarding. If your camera offers a live-view mode, this is the time to use it. If not, shoot the photo and immediately check the LCD playback to see what you've taken. Continue to take pictures and check them until you achieve the look you're after. Before digital cameras, it was difficult to take pictures like this (down low where you can't easily look through the viewfinder), and it often resulted in a bunch of unusable, badly framed pictures. You couldn't see what you were doing or how you were framing your photos. By the time the

film was developed and you saw your mistakes, it was impossible to re-create the exact situation again. The lack of instant feedback prevented the photographer from being able to fix problems in real time. The digital camera LCD has solved all of these problems and more. It is a very powerful tool. Some digital cameras even offer a tilting LCD to make it easier to get the camera into interesting positions.

Get up high and shoot down

This perspective is probably less useful for everyday shooting but is always something to keep in mind, especially if you've tried all other angles and you still have some time to experiment. It will all depend on your location and subject, but some ideas include shooting through the glass of a second- or third-story window, using a stepstool, climbing a hill, and things like that. Always be careful when photographing from up

After shooting in this field of buttercups for some time, I decided to get down low and try looking up at them for a while as kind of a "mouse-eye" view. I think it worked rather well. Nobody ever sees flowers from this perspective, and I love trying to find new ways to illustrate familiar things.

For this picture, I was lying down on the ground, looking up, while my subject leaned over to show me the first leaf of autumn. The result is an interesting—although somewhat odd—perspective. These kinds of views are fun, but I wouldn't recommend overdoing them.

Here's a background that is simple and pretty and *adds* beauty to the photo instead of distracting from it. The green grass and yellow dandelions give a nice feel and help enhance an already interesting portrait.

high. Your safety is far more important than any photograph! Another possibility that is constantly used by photojournalists covering news events is to raise your camera up high over your head to shoot down at the action. Photojournalists like this angle for a couple of reasons. It can give them a clear view of a person surrounded by a crowd. Another benefit is that this perspective can more easily separate the subject from the dizzy background of the same crowd. You might try the same technique in similar situations. Live view can make the difference between the success and failure of this type of shot.

I climbed up into a barn hayloft onto a huge stack of hay to reach a high window to achieve this perspective. I had to brush away all the cobwebs so I could shoot down at this girl and her pony. Notice how this perspective shows off the long shadows of sunset.

Look straight down at someone lying on a floor or on the ground

The ground or a floor can make a great background. It's simple, it's nondistracting, and people rarely take pictures from this angle. It's easy to do if your subject doesn't mind getting a little dusty. Little kids are easy to work with using this perspective because they're often playing down on the ground. Stand near the person (don't let your shadow fall across them if it's sunny), use a mid- to wide-angle focal length (probably around 30 to 50mm), and let the magic fly. I love this perspective.

Use mirrors

Photographers have used mirrors as a creative tool for a long time. There are several ways you can use mirrors in your photography. One common way is to photograph someone as you stand behind his or her shoulder and capture a sharp image of his or her face in the reflection of the mirror. Another possibility is to try a normal portrait that includes a nearby mirror in the room, showing a larger piece of the subject's environment. You should just have fun and see what ideas you get. One thing to remember is not to use a flash near a mirror. If you try it, you'll see why this is not a good idea.

Dynamic Range

Dynamic range (also known as *exposure range* or *exposure latitude*) is the term used to describe how many different shades of light and dark a camera can record at one time. Our eyes have incredible range and are capable of seeing a huge amount of detail, both in deep shadows and in bright areas, at the same time. The camera's eye is much more restricted. A failure to understand this fact has ruined many photographs.

A perfect example is the "person standing in front of a window" example.

- **Step 1:** Photographer A doesn't bother to check his background and snaps an image of his friend, Bob, standing near the kitchen window. However, Photographer B sees the potential problem and moves to photograph Bob from the side to eliminate the window from view and take advantage of its light.

- **Step 2:** Photographer A's camera cannot possibly record all the details coming from this vast range of tones, so it does one of two things: It exposes the background properly so that you can see the lawn, the neighbor's house, the deck, and the trash cans all in perfect clarity, while Bob is left as a dark silhouette. The other scenario is it miraculously exposes Bob correctly, but in doing so, it blows the background out into horrible blank whiteness. Meanwhile, Photographer B is busy having fun capturing Bob's likeness in some nice, pleasing window light. No dynamic range problems here.

- **Step 3:** Photographer A deletes all of his horrible pictures and walks away puzzled over what happened. Photographer B makes a dozen 8x10 prints for Bob's family and later wins a national portrait photography contest because he had the foresight to watch out for a bad situation.

Once in a while, you will find yourself just "falling into" a good shot, where everything is perfect all by itself without any help. My Welsh corgi was sitting on the floor, looking up at me, and I happened to be holding the camera, so I took the picture and that was it. There was no big setup. Light from a large window was coming in and illuminating her from the side, while the simple wood floor gave a good background. Everything just worked.

Use windows

A window is usually your friend when photographing indoors. The key is to remember not to place your subject directly in front of a window. Instead, use the light coming through the window to illuminate your subject without actually including the window in the photograph. Let's repeat this again: Don't include the window itself in your photograph. Only use the light coming *through* the window. There are multiple advantages to this technique. It allows you to work indoors without a flash and creates a more natural-looking image. Using windows that face away from the sun (such as windows that face north) is nice because you are working with reflected rather than direct light; reflected light can create a pleasant, soft mood in the photo.

Composition

Composition refers to the way a subject and its surrounding environment are arranged in a photograph. Good photographers have a knack for arranging these objects in a pleasing way. The definition of "pleasing" can vary from person to person. A photo that one person might think is simply fabulous the next person might not like at all. Still, there are quite a few general things you can do to compose your photos in a way that will make them more striking and interesting. This, coupled with the tips on basic shooting that we've already covered, should help to push your photos to the next level.

Horizontals vs. Verticals

As stated in the previous chapter, you can hold your camera in two ways: horizontally

Moving Around vs. Zooming

Professional photographers once had to work harder than they do now. If they needed a different focal length back when most lenses were prime lenses with a fixed focal length, they had to swap lenses. Photographers had to carry a camera bag that contained a camera body and sometimes four or five different lenses to make sure they would be able to photograph whatever exciting things came up. Zoom lenses existed, but their image quality was not quite up to par with the primes. Photographers would do a lot of extra walking if they wanted to carry only one lens. Without the ability to zoom, photographers had to get close to the subject for a close-up shot. If they wanted a picture of a larger subject, such as a barn, they would have to walk far away and shoot rather than zoom out.

This isn't the case anymore. Today the quality of zoom lenses is excellent. Almost every point-and-shoot digital camera has a zoom lens built in, and you can purchase most DSLRs at a discount when coupled with a kit zoom lens. Zoom lenses offer tremendous creative abilities, as well as the chance to take a wide range of views from the same spot. There is no walking or a bag full of lenses involved.

However, this convenience comes with a price, and that price is what I call the lazy photographer syndrome. Zoom lenses offer great creativity at a fast pace, but they also might discourage you from exploring as a photographer. A much better solution is to work your scene while using your zoom lens. Don't get stuck thinking there is no need to move around and explore all the possibilities just because you can zoom in and out from one place. Be sure to keep moving and finding new angles.

This photo was a perfect candidate for the vertical format. Shooting this way allowed me to come in closer and fill more of the frame with my subject than would have been possible if I'd used the horizontal format.

or vertically. But how do you know when one or the other position should be used? On one hand, we have a wide, sweeping field of view; the other is a tall, narrow frame. Both are equally capable of producing compositions that are good or bad. It's the photographer's job to decide which format is the right one to use at a given time. Holding the camera in the horizontal position (the "normal" position) is also referred to as a *landscape view*, even though you may or may not actually be photographing a landscape. The vertical position (with the camera held sideways) is also known as a *portrait view*, again regardless of whether or not you are taking a portrait of a person.

Many people, including many beginning photographers, don't think to hold their cameras in the vertical format. It might be because all the controls on the camera seem designed for someone taking horizontal pictures. It's likely people just don't think about the option of taking a vertical image.

This is a shame because it means that many people are missing out on the possibility of some excellent compositions.

I decided that this scene would work best as a horizontal photo, since the large geometric pattern of the hay wagon was already longer than it was tall. It was early morning, and I knew I could make an interesting silhouette image of the wagon and farm worker.

This clothesline and laundry lends itself to the horizontal format because the subject (the clothesline) is much longer than it is tall. The intense colors of the laundry create a nice contrast against the primarily green background.

I've found that, on average, I compose about 25 percent of my pictures vertically. That's a fairly high percentage. You definitely want to think about doing the same in order to produce good variety in your images.

Consider the vertical format anytime you are faced with a scene or subject that is taller than it is wide. Portraits of people are fantastic candidates for verticals. On the other hand, long sweeping views of mountains, tree lines, fields, and lakes tend to lend themselves to the wide view of the horizontal format.

Start out by experimenting. Try taking pictures of a variety of subjects in both formats. Shoot what seems natural first, such as a few nice horizontal landscapes, and then switch and take a few verticals even if it seems awkward. You might be pleasantly surprised at the outcome.

Holding the camera in the horizontal position (the "normal" position) is also referred to as a *landscape view*, even though you may or may not actually be photographing a landscape. The vertical position (with the camera held sideways) is also known as a *portrait view*, again regardless of whether or not you are taking a portrait of a person.

The Rule of Thirds

It's easy to get stuck in a rut when it comes to composing your photos. A common one is the "put the subject in the middle" rut. Let's face it. Almost every camera's viewfinder or LCD is designed with a big bold dot or circle right in the middle, just

The rule of thirds works great here because it places the subject in a pleasing position within the frame. Look how the left vertical line runs straight through the girl's body with one of the intersections on her head. Also notice how this composition leaves room on the right side of the photo to give the impression the subject has space to "look into." If the girl was placed on the other side of the rule of thirds (with extra space behind her) the photo would seem cramped and unnatural.

begging to be placed right on Herman's face like a photographic bull's-eye. Making things worse, this dot or circle also usually serves as the autofocusing point. You put the dot right on Herman's head because you want Herman sharp. This results in boring composition. I see this problem all the time where people have placed their subjects right in the middle and have ignored everything else in the image. They often even cut off their subjects' legs or feet in the process.

I'm not saying it's always the wrong idea to place your subject in the very center of the image. I've done it intentionally many times if the scene requires it for some reason. But that is an exception, and you definitely want to consider other methods of arranging your photos. There is, fortunately, an easy way of doing this.

The rule of thirds is a helpful guide to keep in mind at all times. Take a look at my example photo and notice the tic-tac-toe grid lines I've placed on top that divide the photo into nine equal parts. Look at the areas where the lines cross each other.

Notice how I placed the girl near one of the line intersections. She is the subject of the photo. But the subject to which you apply the rule of thirds doesn't have to be a person. It could be a tree, a building, or even a shaft of light—whatever is the most important thing in the photograph.

The idea is to remember these imaginary lines as you compose your images. It usually gives more power to your photograph when your subject is placed near or on one of the intersections. The rule of thirds is a great way to help you start thinking about keeping the focal point of your image away from the center of the photograph.

Be sure to use the rule of thirds on vertical images as well. Take your typical portrait, which is a vertical. It's okay to

position the person's body in the center of the photo, but you'll want to be sure to place his or her face closer to the top.

Special focusing requirements

The rule of thirds brings us to an interesting dilemma. There is a very good chance that if you start putting your subject off-center, the central focusing point on your camera will no longer be in the right place. It will now be pointing at the background. This is a big problem, since we don't want a sharp background with a blurry subject. DSLRs solve this problem by offering the photographer more than one place to put

You can use your viewfinder's focusing points to help you focus on subjects that aren't right in the center of the picture. In the top photo, I've put the flowers directly in the center of the frame and used the center focusing point to achieve sharp focus. But if I want to position the flowers off to one side or the other, I can use either the left or right focusing points to attain my desired look.

the focusing point, but many point-and-shoot digital cameras don't offer this option. The solution is the *focus lock*. (Check your camera's manual and read it carefully because this is an important issue.) Some cameras have a dedicated focus lock button located somewhere on the back of the camera. Other cameras will lock the focus if you depress the shutter halfway and hold. Both methods are used in the same manner: Get Herman sharp before you compose the image by aiming the

Breaking the Rule (of Thirds)

You're probably getting confused. I've just told you that you should use the rule of thirds and begin framing your images with the focal point off to the side. Here I am telling you that it's okay to forget the rules and just do what you want. What gives?

Like all of photography, the only rule is that there are no rules. Whatever makes a good picture goes. Here's one of the very first pictures that I ever took, many years ago.

That was a long time ago, but I still kind of like this photo. There is a little too much vacant space up in the sky, but there are some wispy cloud patterns up there and so not all is lost. The point is that no rule of thirds is being used here. Try whatever you think might make a great photo. Be daring and push your subject off to the extreme edges of the frame. You never know what might happen.

The moral is to experiment. Keep the rule of thirds in mind, especially to help you break the habit of *always* putting your subject in the center, but if you dislike trying to imagine the lines as you compose, just think about keeping those subjects off-center. Your pictures will drastically improve. On the other hand, if it seems more appropriate to place your particular subject in the center, go ahead and try it.

It was a wonderful day for a walk, and I made sure to have my camera with me. This image is one that I had been thinking about for some time, and I was excited to have the chance to try it out. The straight lines of the dirt road lead our eyes right up to the children and then off into the distance.

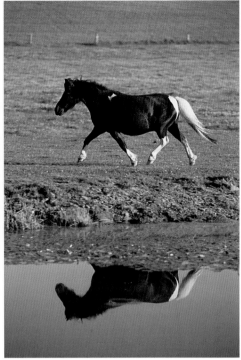

Repetition is a wonderful tool that you can use to help draw attention to your subject. Reflections—when you can find them—can be excellent composition devices. The dual subjects will cause people to give your image a second look.

focusing point at his face, focus the camera, and engage the focus lock. While the camera maintains this sharp focus, rearrange the viewfinder and compose your picture in a more pleasing way. You can move Herman off to the side or put him on one of the rule-of-thirds points and click away. The result is a sharp picture of Herman with nice composition. This technique will help you achieve good pictures all day, every day.

Drawing Attention to the Subject

Let's say you have a great subject and you want to make sure the viewer takes notice. How do you do it? Try some of these other more subtle techniques in addition to the techniques we've discussed (such as sharpness, nondistracting backgrounds, and the rule of thirds).

- **Lines:** Straight lines are everywhere: on roads, down paths, and on buildings. Our eyes naturally tend to follow these lines when we see them in a photograph. Good photographers use this fact to their advantage when composing images. Try to look for scenes where you will be able to use lines to draw the viewer's attention through the image and into the focal point.

- **Framing:** Framing is fun. Try shooting through various objects—windows, branches, cracks, gates, all kinds of things—and purposely allow the viewer to observe what it is they are looking through. If your framing device forces the viewer to look right at your subject, the viewer will have little doubt about the most important part of the image.

63

Here I used the window panes as a framing device. I was on the inside of the building, and the girl was looking in from the outside. The only thing that might have helped this image more is if the window glass had been a bit cleaner!

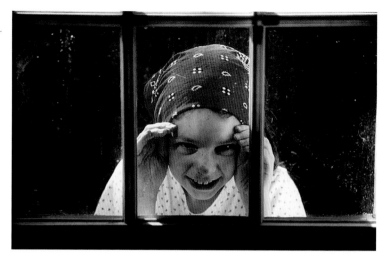

The way this photo is lit helps show off the subject. This standing leaf was lit by the golden tones of a beautiful sunset, while the surrounding grass and other leaves were not so illuminated. I used a Lensbaby lens (see chapter 8) to help enhance the photo's dreamy look.

- **Lighting:** Our next chapter is all about lighting, but for now think about using light to enhance your subject. One of the best examples of this is a singer or actor onstage. The entire stage is dark except for that perfect spotlight shining down on the performer. The audience is left without any question as to who the star is. You can do the same thing with more ordinary light, and it doesn't even have to be that dramatic. Any subtle change in light will enhance your subject and make it stand out from its surroundings.

Enhancing an Image

In addition to the more important aspects that are required to take a good photograph

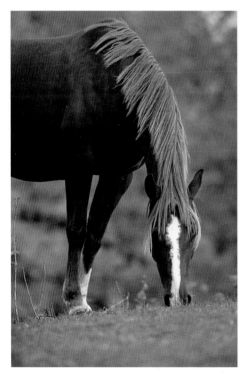

The background color here helps add interest to what would otherwise be a fairly uninteresting picture.

(clean backgrounds, sharpness, composition, and drawing attention to the subject), there are also some subtle things you can do to enhance your final image. These enhancements can be the last push an image needs to take it from being an acceptable photograph to being a great one.

Color

There is a difference between taking color photographs and using color as a part of your composition. Let's take a look at this example image (*left*).

Here we have a basic photograph of a horse grazing. It's sharp, well exposed, not too light, and not too dark. The vertical composition is used in a pleasant way to show off the horse's legs, neck, face, and shoulders. The photograph was taken from a nice, low level and achieved eye contact with the horse. All of this is fine but not spectacular. It doesn't get spectacular until you take into account the fantastic orange background of autumn leaves and *wow*!

The addition of the orange background takes this ordinary image and propels it to excellence. If the trees were an ordinary dark green, it would still be a fine, clean background, but the bright orange changes the entire feeling of the picture. Always be on the lookout for situations like this where you can place your subject in front of an exciting color to draw beauty into your shot.

Combining different colors can also achieve a great look. Red flowers in green grass, yellow leaves against blue sky, pink gloves near purple shoes, all kinds of color combinations can be used to take what would be an ordinary subject and make it something special.

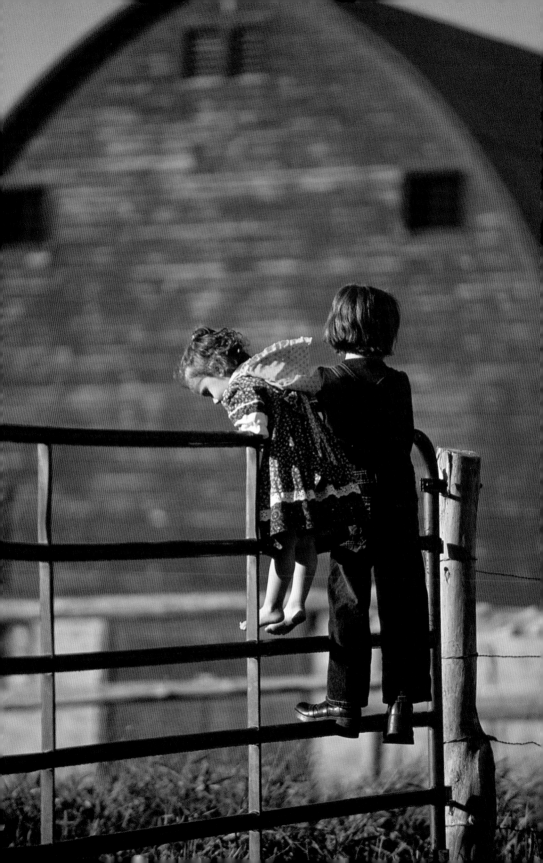

Color and contrast work together to make these leaves stand out against the dim background. Your eye notices the bright green right away because it's the only colorful thing in the photo.

Even if I take away the color and make this a black-and-white image, the effect of the contrast is still there. The leaves are still such a light tone and the background such a dark tone that you can't help but notice the leaves.

Contrast

Working with contrast is similar to working with color, except you're looking at the difference in *tone* between two areas of the photograph. Placing a subject with a very light tone in front of a very dark background (or vice versa) will help you to present a dramatic image. This sample image helps illustrate this technique.

Here we have a photograph of a branch of green leaves taken during late summer. These are not particularly thrilling except for the incredible contrast between the vivid, sunlit leaves and the dark background. Without the contrast, the leaves would have been lost in an ugly background of the same green tone.

Filters

A filter is a piece of glass you place in front of your lens to create an effect. Some point-and-shoot cameras don't allow you to apply any kind of filter to the lens, but all DSLR lenses do. There are many kinds of filters available. Some are useful and some are playful. Here's a quick look at some of the more popular, inexpensive ones.

- **UV haze filter:** An ultraviolet (UV) filter blocks the sun's UV rays from entering the camera, where they can be recorded as hazy, bluish-gray areas on your photographs. Our eyes can't see these rays, but digital cameras can. The rays become most noticeable on landscape photographs when you are shooting objects far into the distance. A UV filter eliminates this hazy appearance. Another reason I recommend UV filters is for the protection of your lens. If you scratch or dent the front of your lens, you will only harm the relatively inexpensive filter that can be replaced with much less financial pain than your lens!

- **Polarizing filter:** Polarizing filters have been a favorite of nature photographers for decades. They have several applications, but one of the best is the polarizing filter's ability to make blue skies a deeper, more intense blue. It will also boost the saturation of the other colors in the scene. A polarizing filter makes pretty pictures even prettier.

Other than a little bit of blue sky near the top edges and some green grass near the bottom, this photo's entire background is red from the big barn. When setting up this picture, I was able to position myself in a way that gave my subjects (the two girls playing on the fence) an interesting background. At the same time, I was able to use this background as a storytelling device—showing the viewer one part of the girls' environment.

I used a circular polarizing filter on this shot to darken the blue sky and make the autumn leaves seem brighter. This type of filter isn't suitable for all types of photography, but you might experiment with one when you are faced with a shot involving a lot of blue sky.

However, the big drawback to using one is that the filter blocks out some of the light entering your lens to make the viewfinder dimmer and reduce the amount of light that the camera has to work with. This is particularly troublesome when shooting action pictures, where the camera needs plenty of light to work. I would suggest trying to borrow a polarizing filter from another photographer and experimenting to see if you enjoy the effects.

- **Skylight filter:** A skylight filter is a piece of glass that is almost clear but has a slight pinkish tint. This can be used to warm up a scene, taking some of the bluish cast out of a cold-looking shady spot or making someone's skin tones look more natural and warm in a portrait. It can also be used as a lens protector, like the UV filter.

Keep in mind that filters, like the glass on the front of your lens, come in various sizes and are measured in millimeters. Be sure to pay attention to this measurement when you purchase a filter. For example, a common filter size is 52mm, which obviously would not be compatible with a lens that uses 72mm filters. Even though the focal length of your lens is also measured in millimeters, this has nothing to do with filter sizes.

Cropping

Some photographers love cropping. They do it all the time to every image. They shave a little off the top of a photo, a little off the side, and keep going until they get the effect they're looking for.

I've never been a huge fan of cropping. I think it is fine in some ways that I'll describe in a moment, but generally speaking I don't like to do very much in the

way of cropping. In fact, for years I was unable to do any. There were no cropping options back when I shot all of my photographs on slide film unless I made a print of the slide and cropped the print. Otherwise, whatever I included in the viewfinder at the time of exposure was there when I got my film back from the developers. This actually taught me a lot. I learned to compose my images tightly and not include anything that I might not want in the photograph. Even with the option to crop images digitally, I find that I rarely do. I think it's important for other photographers to realize that they will walk away with stronger images if they slow down, think about what they're doing, and essentially crop while they are taking the picture in the first place. Frame your images well.

This is an example of too much wasted area near the top of the photo. A simple bit of cropping eliminates some of the unnecessary leaves. We're left with a much stronger image that places more emphasis on our subject, and his face is no longer in the very center of the photo.

Having said that, cropping is a very useful tool in certain circumstances. The main use for cropping is to eliminate small annoyances from your background that you might have overlooked at the time of shooting. Let's say you've done your best and watched your backgrounds, but you went home and discovered there was still some distracting object near the edge of your photo. You can crop that portion off if the offending object has not crept too far into your scene. It helps if this has occurred near the short sides of the image, since that will give you a more natural-looking crop.

It's better and easier to do your cropping on the computer rather than on your finished print. Most types of image-editing software offer some kind of crop feature. This helps ensure your crops are perfectly straight, gives you the ability to see what the possible crop will look like before you actually do it, and gives you a chance to undo the crop if you make a mistake.

Cropping for any reason other than minor adjustments tends to create new problems. Here's a quick example. Julie is too far away from the deer she wants to photograph. Instead of trying to get closer, she takes a picture from her current position. When she gets home she sees that the deer in her photo looks more like a dot than an animal. She tries cropping away all the extra space around the deer and enlarges what is left. This is similar to the digital zoom feature mentioned in chapter 1, and the same problem prevails here. The image resolution drops incredibly, and the photo becomes grainy and noisy. Julie's picture is better than nothing—but not much better! The real solution is to always use a lens that is suitable for the occasion and to get close to the subject initially, even when it's difficult.

LET THERE BE LIGHT(ING)

IN THIS SECTION

This photo is lit from behind. The light source is coming toward the camera with the subject in between. This effect creates an attractive image; the bright golden highlights around the edges of the subject stand out against the darker background.

P hotography is all about light. Good lighting or bad lighting can make all the difference between an average photo and a great one. You can have a picture that is perfect in every other way—well exposed and sharp, with nice composition—but if it is poorly lit, it won't stand out in a crowd of images. Good photographers constantly think about light; they become masters of light. Recognizing how lighting works in your pictures will greatly improve your photography. So to begin with, this chapter takes a look at various types of lighting, including directions, sources, and what kinds of photos would benefit from these lighting variations.

Direction of Light

Light can come from any direction: up, down, left, right, front, back, or even from multiple directions, or all directions at once. Light is flexible. To be a good photographer, you need to be flexible too.

Sometimes you can control lighting by adding something to it (like a flash or a reflector board), but more often than not—especially outdoors—you will be dealing with situations where the quality of the light depends on factors you cannot control. This means you will sometimes need to move either yourself, your subject (if possible), or both to achieve the look you want.

- **Front lighting** is easy to recognize: The subject is lit directly from the front. This isn't usually good for people or

animals because it causes them to squint; however, it is good for people's skin because it can make blemishes less noticeable.
- **Side lighting** is where the light source illuminates roughly half of the subject, with the side facing the light being brighter than the side in the shadows. Textured surfaces become very obvious when lit with side lighting.

Side lighting was used in this photo, lighting up the horse from the left. Light fell only onto her face and neck (the focal point), while the background and foreground remained in comparative darkness. This lighting technique helps to draw the viewer's eyes to the most important part of the photo.

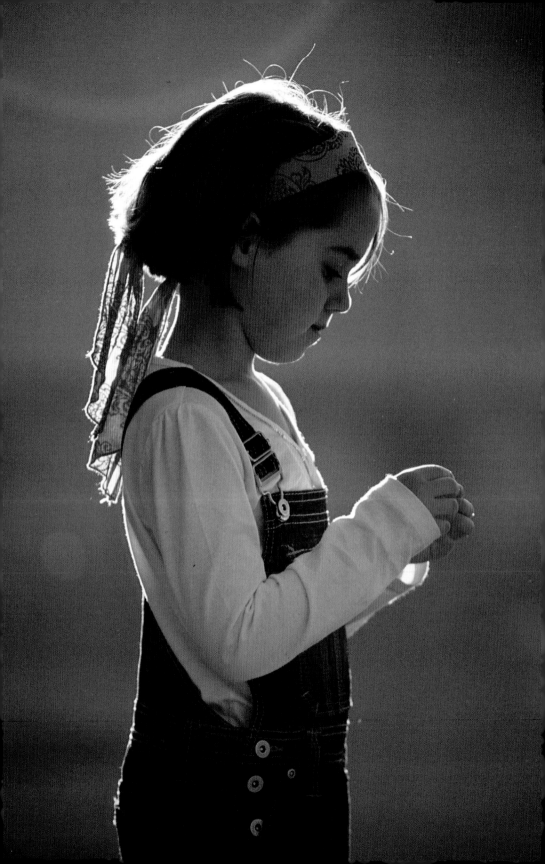

This dog is lit directly from the front. The sun was down low, which cast a strong, golden light straight onto the dog's face and body. I kneeled down low to bring myself and the camera to her eye level. She loves her ball, so I was able to get an interested expression on her face by asking, "Do you want me to throw the ball?"

■**Backlighting** represents a situation where the subject is in front of the light source. Detail may be visible in the subject, but it will be lit by reflected light from the scene, not direct light from the source. This can be a very pretty type of lighting—especially when photographing people, since the backlighting may light up the edges of the subject's hair. A silhouette is an extreme example of backlighting.

In this photo, the sunlight was shining right through the back of the sunflower and making the petals glow. The flower stands out so well against the dark background because the sun was at such an angle that the background was being lit differently than the flower. Always try to find contrasts of light like this and take advantage of them for great pictures.

Even though it was a bright, sunny day, this sunflower was being lit straight on with front lighting, so I was able to get a nice shot without any distracting shadows. I got down slightly lower than the flower and aimed the camera upward to achieve a simple and pleasing blue background.

Opposite: Backlighting worked well for this photo. There was just enough reflected light to illuminate the girl from the front, while the stronger backlighting came from behind and above to light up the edges of her hair and profile. I used a long focal length to help blur the background while keeping the subject sharp.

Light Direction and the Moon

If you watch the moon for a month while it goes through its phases, it can be an interesting lesson in light direction. As the moon moves through its phases, light from the sun strikes it at different angles as viewed from Earth. Sometimes the sun is directly behind us, lighting the moon head on. This is front lighting and gives us a full moon. Sometimes the sunlight is off at an angle, and only part of the moon is lit. This is side lighting and gives us a half moon. As the moon moves in between Earth and the sun, we see less and less of the illumination and see only a sliver of the moon. This is backlighting and gives us a crescent moon. A new moon is completely backlit, with all of the illumination on the side of the moon facing away from us, making the moon invisible to us.

| Full moon, front lighting | Gibbous moon, front/side lighting | Half moon, side lighting | Crescent moon, back lighting |

Natural Light

Moving on from light direction, let's look at different sources of illumination. The location of your light has a significant effect on your photos.

Direct Sun

Contrary to what you might think, shooting on a bright, sunny day doesn't necessarily produce the best pictures, especially at midday. When the sun is overhead and not covered by any clouds, the light coming down is very harsh and hard, which produces very bright highlights and very dark shadows. As you'll recall from chapter 3, this isn't a good situation for cameras because they can't easily record large differences in tone. Most likely you'll find parts of your photo that are too dark and others that are too light. Also, color saturation is affected by bright sun, which can make the entire picture seem pale and dull. Because of this reason, most good photographers put their cameras down between the hours of 10 a.m. and 2 p.m. on

sunny days. If you do find yourself having to shoot in the sun during these times, try out these tips:

- **Shade:** You can get away from the sun's harsh light by working in the shade; however, there are some things I don't like about working with shade. I don't like the colors you get photographing in the shade, I don't like how the white balance comes out, and I don't like the dim conditions in the shade. Now, on the plus side, the shade does eliminate any harsh shadows because the shade *is* a shadow.

- **Fill flash:** Your camera's flash may have a "fill" feature, and this works very well. The idea is that a small amount of flash can "fill in" the harsh shadows caused by a sunny day. The only problem you may find is that the flash can sometimes overdo things and overexpose your photo. This can usually be fixed by simply backing a few feet away from your subject and zooming in to compensate.

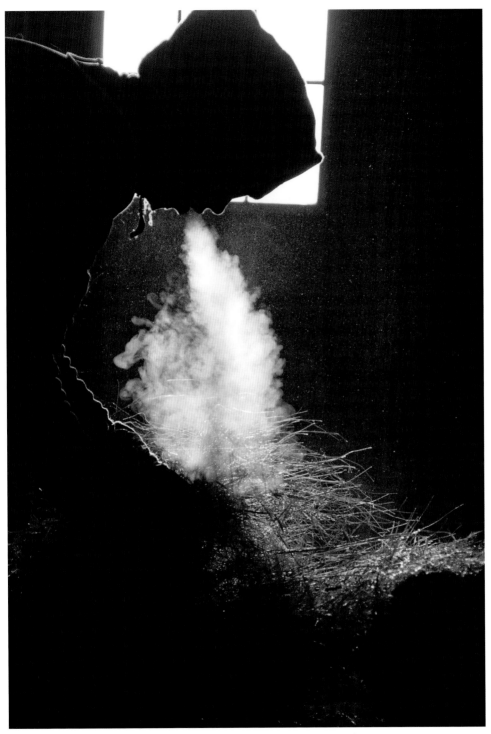

This is a great example of backlighting because you can see exactly where the light is coming from. The only light source is the window in the background. This light is coming straight in toward the camera, creating a silhouette of the subject, lighting up the cloud of breath in the cold barn, and falling onto the bale of hay.

This portrait has a nice composition, and the subject has a nice expression, but the photo fails because it is poorly lit. The bright sun of midday caused harsh shadows.

- **Reflector boards:** True photographic reflector boards can be found at most photo stores. These boards have a shiny surface that you (or an assistant) can use to reflect light onto a subject to fill in shadows, in much the same way as a fill flash, only with less intensity. (Personally, I like the results of photos taken with reflector boards better than those taken with fill flash.) You can also use other items in the same way, like a piece of white cardboard or poster board to reflect the light.

"Golden Hour" Light

All this complaining about the sun only applies *during midday*. Sunny early mornings and late afternoons are arguably the best times for photography of any type. When the sun is down low near the horizon or slightly above it, the light takes on an entirely different feeling, with gorgeous long shadows and a rich,

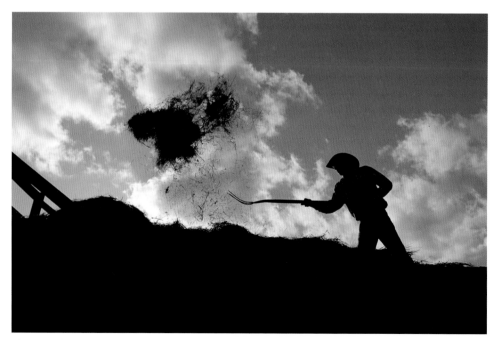

Silhouettes often work well if there is something of interest to look at in the correctly exposed (not silhouette) part of the picture. These great clouds add drama and interest that wouldn't be there if the sky had simply been blue.

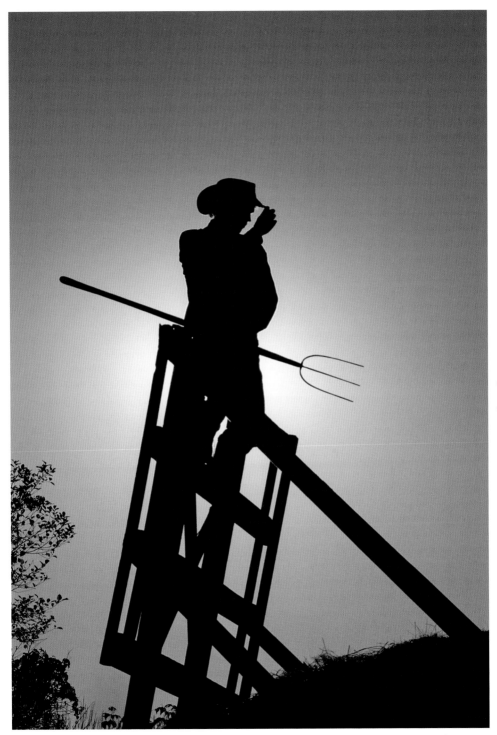

This is a picture of me standing on the hay wagon. I had my brother take the picture, which he did by placing the camera in my shadow down on the ground. By doing this, we knew the sun would be directly behind my body and give us a nice silhouette image.

I took this photo about half an hour before sunset, and I was able to take advantage of some wonderful light. Always be on the lookout for good sunset and sunrise light to photograph in.

This photo was taken in the shade of a tree to avoid the harsh midday light. It works pretty well, but note how the entire picture has a slightly bluish cast—not my favorite look, but better than harsh shadows.

warm, golden tone. For this reason, the term "golden hour" refers to the hour after sunrise or the hour before sunset (although sunrises usually offer a slightly more "cool" light, with less reds and more blues). All photographers aim to work in this light if they can, arranging photo shoots and showing up at pretty locations ahead of time so they can take full advantage of the sun pouring out this perfect light. It's also a great time to try silhouettes.

Cloudy Days

Cloudy days are wonderful for photography. The clouds act as a huge light diffuser for the sun, taking away all or most of the harsh shadows and giving a pleasant feel to nearly all photos. Color saturation is also given a boost by the clouds, making colors seem richer and more vibrant. The perfect cloudy day is usually one where the clouds are slightly diffuse, not overcast. This lets in more brightness and keeps things looking more

Sunny early mornings and late afternoons are arguably the best times for photography of any type. When the sun is down low near the horizon or slightly above it, the light takes on an entirely different feeling, with gorgeous long shadows and a rich, warm, golden tone.

cheerful. A full-blown overcast day with thick clouds isn't so good because things are too dark and you lose some of the color saturation. Windy, cloudy days can be quite fun because the wind keeps the clouds moving around and gives you different kinds of lighting from minute to minute. People and animals often look their best under cloudy conditions. Clouds also make great subjects themselves or can be used to add interest or drama to a scene in which plain ol' blue sky would be boring. For these reasons, clouds are a photographer's friend. (Watch the opening sequence of

The Sound of Music sometime, and note the fantastic clouds mixed in with the mountains behind Maria. These clouds add a dimension of drama that wouldn't exist if they weren't there. The filmmakers used these clouds to achieve this great effect, not to mention keeping down any harsh shadows.)

Don't Believe Everything I Just Said

When photographing snowy scenes, the cloudy/sunny day advice is reversed. Cloudy days in a snowy location do not make good photos because everything looks gray and muted and . . . *blah*. To get any good snow shots, you need some sun working for you, to lighten things up and bring some snap and color back into the scene. Fortunately, for most of the winter, the sun is fairly low in the sky, and this keeps the light at a more suitable angle for photos all day long, even around noontime. Golden hour light, of course, applies during the winter as well as other times of the year.

Don't forget your camera on foggy mornings and days! Fog can be a very interesting environment to photograph in. Just be aware that conditions may be dim, and if it is very foggy, your camera may become damp. This is usually okay as long as you continue to dry off your camera between shots.

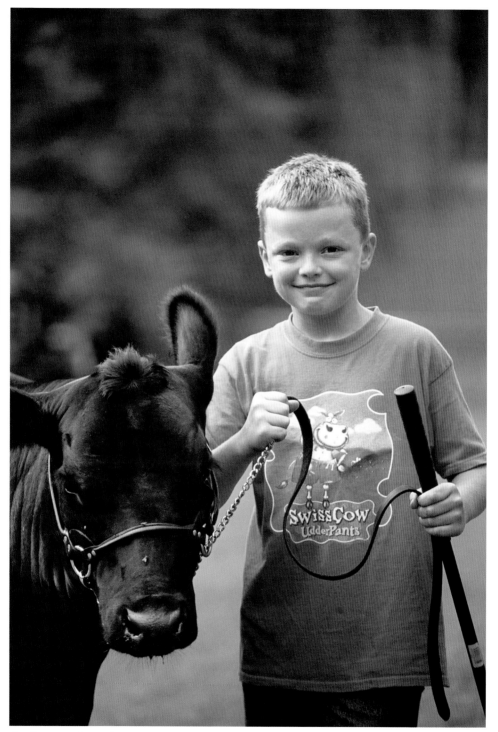

This photo was taken in what I think is just about perfect light for people and animals: a mostly cloudy but not completely overcast day. The clouds were shifting and moving, allowing just enough diffused sunlight to peek through and cast a delightful light.

The Key to All Light: White Balance

Before we look any further at light sources, you need to understand a camera function called *white balance* or "WB." It works like this: Different light sources have different "temperatures." (This temperature doesn't necessarily correspond to any real heat or coolness, although it can.) A light that gives a yellowish/orangish cast, such as birthday candles, is considered to be a "warm" light. A light that gives more of a bluish cast, such

as a fluorescent bulb or the shade of a tree, is said to be a "cool" or "cold" light. In between warm and cool/cold, you have sunlight, which gives off a normal white color.

Generally, your eyes don't notice the color of light because your brain adjusts the scene to make the light appear to be normal, no matter what the "temperature." Your camera can do the same thing for your photos by correctly setting its white balance. If the camera recognizes a scene lit by cool light, it compensates by setting the white balance

Remember that you can use unusual cloud patterns to add interest to your photos. In the top photo, I positioned myself in such a way that the large clouds in the background were placed directly behind the windmill. In the bottom photo, approaching storm clouds helped achieve a deep-blue background.

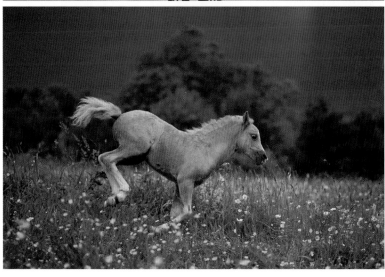

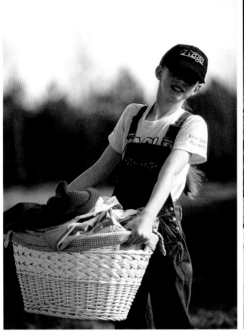

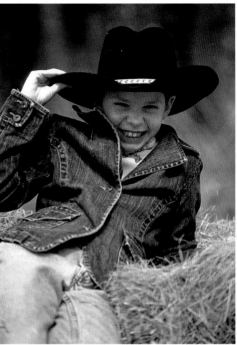

Be aware of people wearing hats, since the hat's rim or visor may cast a shadow right across your subject's eyes (*left*). Shooting on a cloudy day or using a fill flash can eliminate the problem (*right*).

to a warmer setting. If the camera sees that the light is warm, it tries to select a cooler white balance setting. Such camera-controlled adjusting is known as auto white balance.

Auto white balance works pretty well most of the time, but like every other automatic camera function, it sometimes makes mistakes. The camera may not recognize the color of a fluorescent bulb, leaving you with an odd, bluish photo; or it might over-adjust a warm scene and give your photo a blue cast that wasn't really there. Sunsets are a great example. A brilliant sunset might have wonderful reds, oranges, and pinks—all very warm colors. When auto white balancing sees this warmth, it thinks, "Whoa, got to tone down on the reds." So it shifts the white balance to a cooler temperature, accidentally robbing your photo of all those great colors. When

things like this happen, you need to take over and manually set the white balance.

This is quite simple to do. Digital cameras have a control (usually accessed through a dial-button combination on a DSLR body or through a menu system on a point-and-shoot) that allows the user to tell the camera exactly which white balance to use. These settings are known as "white balance presets." Common presets include the following:

- **Daylight:** This setting is for sunny days. It works for most scenes, and I use it more than any other WB setting, even auto. It is also useful for sunrises and sunsets.
- **Cloudy:** This setting is for cloudy days, although it actually works best for overcast days. Days with half clouds/half blue sky look better when shot with the normal Daylight setting.

- **Shade:** This setting is for photos taken in the shade. I don't like this one too much; I find that my camera overcompensates for the blue tone in the shade and gives me orangish pictures that are too warm. Yuck.
- **Tungsten:** This setting is for use under regular incandescent light bulbs. Auto white balance usually gets this right all by itself, so you probably won't be using this preset.
- **Fluorescent:** Fluorescent lighting is tough, so check the next section about working with this type of light.
- **Flash:** Camera's flashes are supposed to be white, like daylight, but tend to come out a bit too cool—too blue. The Flash preset can be used to warm things up again. Personally, I rarely use this preset.

You may find out later that a particular photo came out with the wrong white balance. Regardless of whether it was auto's fault or your own for choosing the wrong preset, pictures are sometimes just "off." If this happens, you can usually save the day by making adjustments to the white balance using photo-editing software. Look for sliders named things like Tint and Temperature, and try making some minor adjustments to them to see if that helps. One good technique is to find an area or spot in the photo that you know is supposed to be pure white and watch how the sliders affect this spot. Some photo-editing software will even allow you to use a pointer (known as an "eyedropper") to show the computer an area that should be white and click on it, and then the software will set the proper white balance all by itself. Very handy.

Sunrises and sunsets can often come out too blue when photographed with auto white balance (*left*). To solve this issue, manually set your white balance preset to Daylight. Your photos will then retain their natural colors (*right*).

LET THERE BE LIGHT(ING)

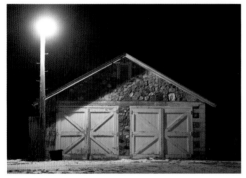

In the original photo, my camera's auto white balance (*top left*) was fooled by the scene's fluorescent lighting. The entire picture came out with a strange green cast. Once I got the picture in my photo-editing software (*top right*), I used my white balance eyedropper tool to zoom in and click on a part of the photo that I knew was supposed to be white. In this case, I chose a piece of a door. Doing this instantly restored my picture back to the colors that I originally saw when I was there (*left*).

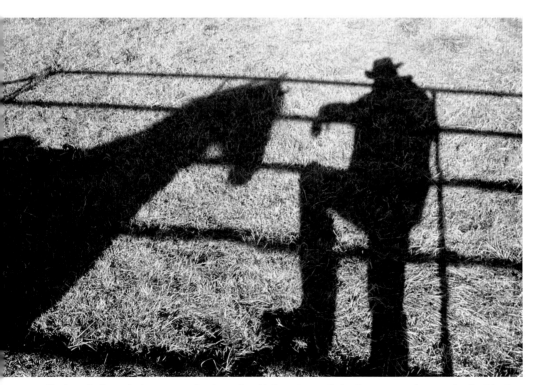

That's my shadow—the human one—leaning against this fence. I was pointing the camera at the ground and waiting for just the right moment as I tried to encourage one of my horses to come up and get in the picture with me.

Indoor Natural Light

There are plenty of light sources indoors as well. Even though these light sources may be manmade, we can consider them to be natural light because they aren't created by the photographer.

Tungsten Lighting

Tungsten light is the term used to describe a regular incandescent light bulb. Houses are full of these types of bulbs, and they can be relied on to illuminate a room in a generally pleasant way. The biggest problem with tungsten bulbs for photographers is that they usually aren't very bright, and you may not have enough light from them to make a good picture.

Tungsten light gives a very warm glow, with a yellowish cast. You probably don't notice the yellowish cast because your brain adjusts the scene for you, but your camera will be very sensitive to it. Depending on the scene, you may or may not want the warm tone of tungsten light. If you want to keep the yellowish cast (and it can be very pretty), set your white balance to Daylight. If you decide you don't really want the yellow tone, choose Auto or Tungsten.

Fluorescent Lighting

Fluorescent bulbs are becoming more and more widespread, so don't be surprised to run into situations where your shooting area is illuminated by this type of lighting. Many large indoor areas like gymnasiums and most indoor sporting venues are lit by fluorescent light. Unfortunately, fluorescent light is one of the hardest lights in which to photograph. It can give a bluish, purplish, or even greenish cast to a scene, and even though your own eyes probably don't notice the difference, your camera's white balance is going to have a tough time handling it. Pictures taken in fluorescent lighting often come out with weird colors, so take one shot and check your LCD to see how auto white balancing did. If there's trouble, you can try the Fluorescent preset, and then if the photo *still* looks odd, just go with it and try to fix things later with your photo-editing software. I hate to make the suggestion to rely on fixing things later with a computer, but you may not have a choice with this type of lighting. The easiest solution is not to take photos with fluorescent lighting; go somewhere else if possible! If you have no choice (like a graduation ceremony in a gym), then just go for it and see what happens—but be prepared to have to make adjustments back at home with your computer.

Windows

Window light is typically easier to work with than tungsten or fluorescent lighting. First of all, a window usually produces a lot more

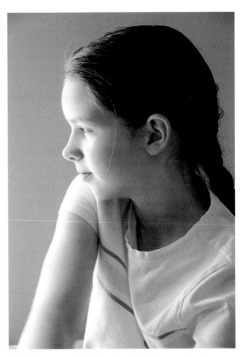

This indoor portrait is illuminated by light coming in through a window just off the left side of the photo. Because the sun wasn't shining directly through the window, the light has a soft white glow that I like very much.

light than a light bulb. Secondly, the color of the light is a more normal temperature, so your camera has an easier time setting the white balance. If you want to take a picture of a room illuminated by light coming through the window, frame the shot to include the whole room, even the windows. Then, set exposure compensation to +2. This way, the room will come out exposed properly, even though the windows are washed out. If you want to use window light to illuminate a subject (such as a person), don't include the window. Only use the window's *light*. (Auto white balance can usually handle window light correctly.)

Shadows

Shadows can be a fantastic tool in photography. We've already seen the trouble that shadows can cause on sunny days, but shadows can also be very beautiful, adding drama and depth to a photo.

Try to start paying attention to shadows: how they move, how they strike various objects, and how their length is affected by the angle of the light source. For instance, when the sun is low on the horizon during the golden hour, shadows are very long and stretch far away from the object casting them. The higher the sun rises, the shorter the shadows become; at the same time, the shadows' direction changes as well. All of this can be used to add beauty and detail to your photos.

Shadows can make good subjects in and of themselves, but you have to be very sure that the shadow is obvious and easy to see; otherwise your viewer might miss the point of the picture and only see the background that the shadow has fallen onto. Shadows on "blank" backgrounds can be very effective, such as shadows cast onto snow, walls, or grassy fields.

Electronic Flash

Why Use a Flash?

A flash is a brief burst of light released through a lighting device on top of the camera, or built into the camera. This burst of illumination is used for the following reasons:

- To add light to a scene that is too dim.
- To "fill in" harsh shadows on a sunny day.
- To give the photographer full control of the direction of light in the photo.

Nearly all cameras—short of the full-pro DSLR models—have a flash unit built into them. (The pro models don't because pro photographers usually don't like the results from built-in flashes. They prefer external units, which I will discuss in a moment.)

Limitations of Flash

A typical flash can only illuminate subjects that are a short distance away from the camera. Beyond that, things get dark fast. Likewise, if a subject is too close to the flash, it will usually be overexposed (way too bright). A great example of this is a flash photo taken inside a restaurant during a family reunion. Somebody goes to the head of the table and tries to get everyone in

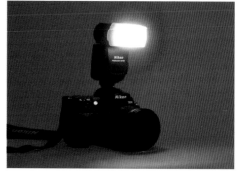

An external flash unit connects to a DSLR using a hot shoe. These types of flashes work well because they're powerful, they're fast, and they cause the light source to come from a point farther away from the lens than is possible using a built-in flash. All of these features help you take better pictures.

the picture. But the flash's light can't reach that far, so the result is that the people nearest the camera are overexposed, the people at the middle of the table are lit properly, and each person farther down the row becomes darker and darker until we can't even see the people at the other end. This is known as flash fallout. Be aware of this limitation and don't expect distance miracles from your flash.

Achieving Nice Flash Pictures

The first thing you can do to help achieve a good-looking flash photo is to avoid getting too close to your subject so you don't blast it with light. Then, try to add some other light source aside from the flash itself (like windows or other natural light). Another good thing to remember is that flashes have to be charged up a bit before they can fire. This is because a flash takes up a lot of electricity. Each time you shoot a flash picture, several seconds must go by before you can take another. If you try to shoot again before the flash is ready, the camera probably won't let you take a picture. This delay is known as the flash's "recycle time." Learn to be aware of how fast your flash recycles so that you aren't caught unprepared.

Red Eye

We've all taken unflattering flash pictures of people whose eyes have been turned red by the glare of the flash going off. This is one of the most complained-about problems in all of photography, and it is almost always preventable. Here's how:

- **Trash the flash!** The simplest way to avoid red eye is not to use the flash to begin with! Just turn it off. If you don't use the flash, you can't possibly cause red eye. If the scene is too dark to work without a flash, put your subject near a window, or go outside, or turn on all the lights in the room, or put the person by a lamp, but do something instead of blasting them with a

> The simplest way to avoid red eye is not to use the flash to begin with! Put your subject near a window, or go outside, or turn on all the lights in the room, or put the person by a lamp, but do something instead of blasting them with a flash.

flash. Even if you do end up using the flash, adding other light sources to the subject will help keep red eye to a minimum.

- **Red-eye reduction mode.** This is a flash mode in which the camera tries to make people's eyes less susceptible to red eye by firing a little flash first, just before the main one goes off. This doesn't work very well, in my opinion. The subject usually thinks that the little flash was the photo being taken, and he or she starts to move away just as the real flash goes off. You may have different results, so try it out, but don't raise your expectations too high.

- **Post-production red-eye removal.** Most photo-editing software offers a way to repair red eyes that are already in a photo. This involves clicking on the offending eyeball or drawing a circle around the red spot and then letting the software run its magic. Typically this works fine—but never as well as avoiding the red eyes to begin with.

External Flashes

External flashes are big, powerful flash units that can be mounted on top of your DSLR's hot shoe plug. A hot shoe is mounted on the top of a camera where a flash can be attached. Most point-and-shoot cameras cannot use external units; they are restricted to their built-in versions because they do not have a hot shoe (see chapter 1 for many photos showing the various parts of a camera). An external flash is

superior to a built-in flash for several reasons. First of all, an external flash is tall, and having a light source that is up in the air, away from your camera lens, is helpful in taking better photos. External flashes also eliminate the old red-eye problem because now the light source is a bit farther away and is not shining directly into the person's eyes. Also, external flashes often recycle faster than built-in flashes. The problems with external flashes are that they can be expensive, they're usually heavy, and they take up a lot of battery power. But the results are superior to those of a built-in flash.

Bounce, Baby, Bounce!

External flash units can usually bend and twist at the top, allowing the photographer to aim the light in various directions. This can be helpful indoors because you can use this bending function to "bounce" light off a wall or a ceiling. It works like this: Ron's whole family is visiting his house at night after dinner. Ron decides to grab a few quick shots of Aunt Barbara and Uncle Dick, but the room is too dim. There

Quick Tip: Try This Trick

For those of you working with a point-and-shoot camera and a built-in flash, you can try this trick to help reduce the harsh light given off by the flash. Fold a small piece of (white) tissue, napkin, or paper towel and fasten it in front of your camera's flash. This will help soften the light and give your photos more professional-looking results.

just isn't going to be enough light to make a satisfactory image, which means that Ron is going to have to use his flash. But rather than blasting Barbara and Dick with a head-on flash, Ron cleverly adjusts his external flash unit so that it is pointing slightly upward, more toward the ceiling. Now when Ron clicks the shutter, the flash goes off, but the light bounces off the ceiling first before illuminating his aunt and uncle. This makes for a much more pleasing picture, with a soft, diffused light instead of a loud, harsh one.

Here are two flash pictures that I took during the same shoot. In the first portrait (*left*), I used my external flash in its normal position—pointing straight at the subject. The light is hard and somewhat unflattering. In the second portrait (*right*), I used the bounce technique to aim my flash at the ceiling. This caused my subject to be lit by reflected light bouncing off the ceiling, and this made for a much better portrait.

MANAGING DIGITAL IMAGES

It's time to get those photos off the camera card and into the computer where we can work with them. Along the way, we'll learn about digital photo management and file types.

It's common to take lots of pictures, leave them on your camera forever, and never look at them again. Unfortunately, this is what happens sometimes to people who buy digital cameras. They shoot, have fun, and never deal with the photos they've taken. Enjoying your photos isn't easy when all those wonderful images are trapped inside your camera and only visible on that tiny LCD screen. In this chapter, I'll explain the ins and outs of managing your digital images so that you'll be able to enjoy them for years to come.

File Sizes

Image files are measured in various sizes. The smallest of these is the **kilobyte** (KB). Any very small photo or one that has been compressed for e-mail or Internet use will usually be measured in kilobytes, such as 30 KB, 150 KB, 500 KB. Further, 1,000 KB equal 1 **megabyte** (MB). Most high-quality photos straight out of a digital camera will probably be anywhere from 2 to 10 MB in size (although this can vary greatly depending on the camera and the file type used). Then, 1,000 MB equal 1 **gigabyte** (GB). Large storage devices like blank DVDs or hard drives are usually measured in gigabytes. Finally, 1,000 GB equal 1 **terabyte** (TB). Very large hard drives are measured in terabytes.

Here's a list of file types that one of my photo-editing software programs offers. JPEG and TIFF are familiar enough, but what's a PNG or a TARGA? You may run into programs that let you save pictures in these other formats, but I would recommend that you stick with the more widely used file types: JPEG, TIFF, or RAW.

File Types

The first thing you need to know about digital photograph files is that they come in three types, each with its own advantages and disadvantages. Image files are ordinary computer files that just happen to store photos. But in the same way that a document file created on a word processor is different from one created on, say, a desktop publishing program, there is also more than one way to store a digital image in a file. Let's take a look at the three main file types.

- **JPEG:** The JPEG is named after its inventors, the Joint Photographic Experts Group. JPEGs are the most widely used image type. Everybody uses JPEGs: We e-mail them, we print them, we put them in our phones, and we put them on our websites. The reason for the JPEG's popularity is that every computer and camera can read this type of image file, and the format gives photographers a lot of possibilities as far as file size is concerned. JPEGs do

this by offering compression options to the photographer—a quick way to make an image file take up less space. These quality settings are usually called things like Fine, Medium, and Low, or something similar. The difference between these settings lies in how much image information each setting retains. A Fine JPEG will hold almost all the image data available when the picture was taken, while the Low setting will make the image file very small. More on this is a moment.

- **TIFF:** TIFF is short for Tagged Image File Format. TIFFs have been around longer than JPEGs and are often used by professional photographers and publishing companies that print books and magazines. A TIFF file is almost always larger than a JPEG, and this is because it holds more information. It's a fairly safe statement to say that if you have two identical images, one stored as a JPEG and one stored as a TIFF, the TIFF will be of higher quality, though this difference may or may not be obvious to the viewer.

Here are two versions of the same photo, a cute Jack Russell terrier puppy that I photographed next to some sunflowers. The photo on the top shows what happens if you apply too much JPEG compression, while the bottom photo shows a normal version. As you can see, too much JPEG ("lossy" because you "lose" quality) compression causes tiny squares to appear all over the puppy's face, losing fine detail in the process. These squares are known as "artifacts." I call them "JPEG squares."

- **RAW:** RAW files are images that have not yet been processed by the camera. (RAW is not an acronym for anything, and no one knows why we capitalize it. Maybe just because it looks cool that way.) You can't view these types of images without using a special piece of software known as a RAW converter. RAW files are useful because they let the photographer make some decisions on how to handle color, white balance, and exposure *after* the picture has already been taken. This is very useful but much more time-consuming.

So, which type of image file should you use? Until you have more experience working with image files and image-editing software, stick with your camera's good old JPEG setting. Just be sure to always set your camera to its highest-quality JPEG setting

The reason for the JPEG's popularity is that every computer and camera can read this type of image file, and the format gives photographers a lot of possibilities as far as file size is concerned.

(usually called High, Fine, or Best). This is so that you will be taking full advantage of that expensive sensor inside your camera. You can always use Save As to make a lower-quality copy of an image later.

Building from RAW Materials

After you've become experienced with using JPEG files, you might want to try your hand at processing a RAW file, if your camera allows you to shoot them. (Check the manual to find out.) You'll need a RAW converter, which may be supplied by your camera's manufacturer or some other software. Even though it is slightly expensive, you might want to look into purchasing Adobe's Photoshop Elements, a very popular image organizer, editor, and RAW converter. You'll be amazed at how much control you will have over the color and tone of your photographs when you shoot them in the RAW file format. On the other hand, you may be perfectly happy with your JPEGs, and that's just fine too. If you are interested in working with RAW files, make sure that you experiment with them in a controlled setting, just in case you run into problems. Start out by testing your RAW capabilities with pictures of something unimportant, like a tree, until you get the hang of it. Don't sit in the aisle at your sister's wedding and think, "Oh, I've never shot RAW before—I'll start now!" If you goof up, you'll miss all those precious memories.

Hey, There Are *More* Than Three Types of Image Files

You may run into other image file types than the ones mentioned in this book. This is because there are a handful of older, on-the-verge-of-being-forgotten types of image files that have been made obsolete by the aforementioned three file types. Some of these files you might see include Bitmaps (.BMP), .PCX files, JPEG 2000s (.JP2), and Graphics Interchange Format files (.GIFs). By all means go ahead and view older pictures that are saved in these formats, but I wouldn't suggest saving your own images into any format other than as a JPEG or TIFF. You want your images to be viewable far into the future, not buried away in some long-forgotten (and unsupported) file format.

The LCD menu on the back of my DSLR lets me choose from a variety of resolution and file-type settings. I can choose Basic, Normal, or Fine JPEG files; I can choose RAW files; or I can tell the camera to shoot a combination of both. Here I've selected the plain RAW setting, my personal favorite.

Two Image File Analogies

Image Files Are Like Vehicles

- **A JPEG is like a car.** You can make it in different sizes. You can have a large car that hauls lots of stuff (image data), or you can sacrifice storage room to make the car smaller and speedier. You could even make a race car (lots of compression) that can hold almost nothing except its driver (little image data) but can move very quickly (small file space, quick for e-mailing but lacks quality).

- **A TIFF is like a truck**—a slow, clunky moving truck. But that truck has all kinds of room inside to haul stuff (extensive image data). The truck is huge and takes awhile to get where it's going, but it can move *everything*.

- **A RAW file is like the inside of a car factory.** All the parts are there, just waiting to be put together, but as of yet you only have a pile of wheels, gears, and belts. The car has to be built by a RAW converter before you can do anything with it. But the factory gives you all kinds of control; you can decide to build a truck, or a moving van, or a family car, or even a speedy little racer. And you can rebuild that car over and over, in different ways, without ever losing quality. The problem is that you have to invest the time to build your car, instead of having it delivered to you all finished in the JPEG or TIFF form.

Image Files Are Like Music

- **A JPEG image is like an MP3 file.** They both represent compressed versions of the original data, retaining *most* of the quality but dropping some in order to make the file size smaller for faster handling over the Internet, or to save disk space.

- **A TIFF is like a CD**, with all the original data intact just the way it was intended by the producer. In just the same way you can rip music off a CD and make a compressed MP3 for your music player, you can make small JPEGs (or big JPEGs) from a big TIFF.

- **A RAW file is like a recording studio** where the singer and the band have made separate recordings, but those recordings haven't been blended together yet. The studio technicians will have to use their equipment (their RAW converter) to make a finished CD or MP3 (TIFF or JPEG).

Squeeze Me In: Compression Explained

Compression is a method used to reduce file sizes. Compression removes unnecessary or redundant digital information from the image. It works like this: Let's say Ron has a terrific picture of Aunt Barbara. It's so good that he decides to save it as a TIFF. But the resulting file size is huge, so Ron decides to apply a little compression to the photo.

One way to do this is to save the image as a TIFF file with "LZW" compression (compression options are given to you any time you use the Save As command). When a TIFF image is saved with LZW compression, the computer writes shortcuts for itself without actually "deleting" any data. For example, part of the computerized information that makes up the photo (a piece of Aunt Barbara's nose, perhaps) is represented by a string of binary language, like this:

00011010010000000000000000000000110.

Now, a picture is worth a thousand words, but in the case of a digital image, a picture may be worth millions and millions of those 1s and 0s. Every single one of those numbers takes up space on the camera card or computer hard drive. One way to get rid of some of them and make things more compact is to have the computer ignore the long strings of similar numbers and write them out like this instead:

00011010010(21)110.

This is a lot cleaner, with fewer numbers for the computer to store. LZW compression tells it to forget all about that long string of 0s and just make a note that there are twenty-one of them. Doing this saves all kinds of file space. This kind of compression is called *lossless compression* because it makes the file size smaller without actually losing any detail. I can often take a large 30-megabyte (MB) TIFF and use lossless compression to reduce the file size down to around 8 MB. We don't ever actually get to see these 0s and 1s; the computer does all the work for us. The photographer only decides when to use LZW and when not to.

Fine and good, but lossless compression can only go so far. To *really* squish down pictures, we have to use *lossy compression,* which is the type of compression a JPEG file uses.

Let's take Ron's photo of Aunt Barbara again. Now that he has his high-quality TIFF saved, Ron wants to e-mail a smaller version of the photo to Aunt Barbara, so he uses Save As to make a small JPEG of it and lets the computer apply some lossy JPEG compression. What does the computer do to achieve this? Basically, it looks over the whole picture for colors that are almost the same shade and blends them into a similar color. For example, one pixel might be completely white. The next one might be almost white, but not quite. Another might be off-white. Another might be more of an ivory. Still others might be gray-white, wall-white, or dove-white. The computer looks at all these and says, "Forget it! Close enough! Let's just make them all the same shade of white!" Doing this reduces the file size greatly because all those individual whites don't have to be described one by one. The computer can just look at this whole generally white area (like a piece of a blank wall) and say, "Okay, fine. This entire spot can be the same color—just a

general white." Our eyes are more interested in the brightness of a color than the exact shade, and so the JPEG compression formula puts more emphasis on getting rid of extra colors than extra brightness. The resulting file is an image that contains *most* of the original information but not all of it. Exactly how much data is thrown out can be controlled by the photographer, by using Fine/Medium/Low quality settings. You can get a file down to a very small size, appropriate for e-mailing—perhaps 30 kilobytes (KB). You would never want to try to print a photo from this type of compressed file, but it works great for e-mailing a photo and viewing on the computer screen.

(This isn't an *exact* description of how compression works, but the full truth is long and boring and really of no point for the scope of this book. But this is basically what happens.)

We're Not Having an Argument, Just a Little TIFF

So, if you're only ever going to be shooting with JPEG (or possibly RAW) settings, what good are TIFFs? What can they possibly be used for? The answer: for archival storage. Let's say you just took the most amazing picture of your career, and you want to make sure it is preserved forever at the utmost top quality. What would be the best method? The answer: a TIFF.

One of the more undesirable characteristics of the JPEG file type is the fact that every time you open and resave one, you lose just a little bit of image quality (though you probably won't be able to see this immediately). Even when you're using the highest quality setting, the computer still sends the picture through another round of compression and throws away a little bit more image data every time. A TIFF doesn't do that because TIFFs are said to be "non-destructible." TIFFs stay strong and solid in the face of repetitive reopening and therefore are a better option for long-term storage. So the next time you get that terrific once-in-a-lifetime picture, you might consider using your image-editing software to save it as a TIFF.

Resolution

In digital photography, the term "resolution" refers to how many *pixels* (dots) are in a digital photo. The more pixels, the higher the resolution, and the better your picture is going to look no matter what the circumstances. Unfortunately, high-resolution (hi-res) photos make for very large image files. They take up more space on your hard drive or camera card than low-resolution (lo-res) images. Sometimes people shoot low-resolution photos in order to fit more images on a card. But this isn't a good idea.

This point-and-shoot camera doesn't allow RAW files to be taken—only JPEGs. But it does offer a variety of resolution settings. You'll always want to select the highest quality setting that your camera offers.

Most photo-editing software offers you a simple way to reduce the resolution of a picture later on, in case you want to have a smaller version available for e-mailing or Internet use.

Pro photographers demand high resolution. This is because pros always want to maintain the highest possible image quality *just in case*. They never know when an image might need to be reproduced at a large size—perhaps in a calendar, or on the cover of a book, or even blown up on a poster or billboard. If the pro had previously diminished the quality of the image by reducing its resolution, he or she would be forever out of luck and wouldn't be able to make the sale of the photograph.

I recommend that you aim for high resolution as well, at least at the time you take the picture. Avoid shooting photos at the Low or Medium quality setting because these settings will reduce your image's resolution. Always use the best quality setting possible. There is a good reason for this: You never know which picture you will love the best, and you never know when you might want to make a big print of one of your images. Look at it this way:

Ron and Sarah go out for a walk with their cameras. Neither expects anything spectacular to happen; they're just having fun. Sarah decides not to use up excessive space on her card (or her computer later), so she shoots JPEG files at a low-resolution setting. The pictures are just for fun, right?

Ron, however, doesn't want to get caught unprepared in case some wonderful photo opportunity presents itself. He keeps his camera set to high-quality JPEGs. He knows he can always delete boring pictures later to clear up disk space.

Then, of course, something terrific does happen—a perfectly wonderful bald eagle flies right over their heads—and Ron walks away with some terrific high-resolution images that can be printed out nicely, while Sarah is left with low-resolution photos that only look good when played back on the camera's LCD screen, and even then they are kind of fuzzy. Learn from Sarah's mistake, and always shoot your photos at the best quality your camera can dish out.

Digital Camera Cards

Various digital cameras can save images onto a variety of different card styles. The oldest is the Compact Flash card, known as a CF card, which is commonly used in high-end professional cameras. The most common card style is probably the Secure Digital, or SD, card, which is used in many point-and-shoot cameras, as well as a few smaller DSLRs. Other card types exist, such as the xD-Picture card by Fuji and Olympus and the Memory Stick by Sony.

None of this will matter much to you because the style of card you use is already determined by your camera's requirements. Just read the manual to find out what type of card to buy. Obviously, if your camera uses the SD format, you won't need to buy any CF cards. Simple. (Who said digital photography had to be difficult?)

One thing you do need to think about is card capacity. There are a lot of sizes to choose from, so what should you buy? Obviously, a high-capacity card can hold more pictures. These cards are more expensive, but you won't have to buy as many. Also, it's more convenient to go off shooting for the day and have everything fit onto one card without changing it each time one gets full. However, this method also has its disadvantages. Let's watch Ron for a moment to see why.

Ron buys a huge 16-gigabyte (GB) card, enough to hold thousands of JPEGs. He shoots for a month or two, until one day when he finally fills the thing up and stops to change cards. Unfortunately, Ron is standing on a bridge when he attempts this, with the rushing rapids of a river directly below. Oops! The tiny card slips from his fingers and vanishes, taking two months worth of fabulous pictures along

Camera cards come in a confusing assortment of styles, sizes, and speeds. Be sure to do your research and select a card that fits your storage and speed needs without being too expensive.

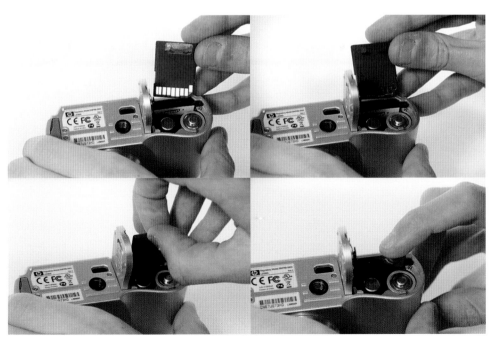

On most point-and-shoot cameras, the card slot (place where the card goes) is located next to the batteries inside the battery door. Cards and their doors are often delicate devices, so work carefully when inserting and removing a card.

with it. (Ron *should* have been backing up his photos all this time.) For this reason alone, it isn't always wise to buy the biggest card around. If your images from the day or week are spread around on more than one card, you can't lose *all* your recent images at once, should some disaster strike.

By the way, your camera card will come with a little plastic case that's just begging to be thrown away immediately. Don't do it! Those little plastic protectors can keep your unused cards safe from electrical shocks and dust. And, if you're going to be around water like poor Ron, you can purchase floating card protectors—which are life preservers for camera cards.

Another factor that might play into your choice of camera cards is card speed, which is how fast a card can read and write data. Card speed is displayed using the term "×," as in "150×" or "300×." The higher the x number, the faster the card will perform. Naturally, you'll want to buy the fastest card you can, but the price goes up according to speed. You'll have to find the right balance of speed versus budget to fit your needs.

Formatting Camera Cards

It's important to remember that you shouldn't shoot photos using one camera and then take the card out and put it in a different camera to continue shooting. Doing this can cause the card to become rather mixed up because both cameras are trying to stash pictures away in different places. This situation can lead to card corruption. The same thing can happen if you constantly take a lot of pictures, put them on your computer, and then just delete them all off of the card. In both cases, what you really need to do is *format* the card. Formatting clears away all the pictures and folders and lets the camera start off with a clean canvas. Just make sure you have all the pictures safely backed up on your computer before you format, as explained in this next section.

Managing Digital Images

Here's what is going to happen: You're going to shoot oodles of digital pictures, take them home, and dump them onto your computer's hard drive where they will become all jumbled up into a horrible digital mess. You'll never be able to quickly find the

It's important to format your camera card periodically in order to keep it running smoothly. Formatting deletes all pictures from the card, so make sure you stay away from this menu option until after all of your photos are safely backed up somewhere else.

pictures you want, when you want them. Perhaps this has already happened to you. What can be done?

Getting the Images Off of Your Card

You may already know how to transfer images from your camera to the computer, but for those who don't, there are two ways to get your digital images onto the computer. The first method involves connecting your camera to the computer with the camera's USB cord (you will probably have to install the camera's supplied software to accomplish this) and transferring your pictures onto the hard drive. If you do this, make sure that the camera has fresh batteries or is plugged into the wall using an AC adapter. This way, the camera's batteries can't go dead while you're transferring your images, which could result in the corruption of your camera card and the loss of some—or all—of your photos.

The second way to retrieve your photos is to take the camera's card out of the camera and plug it into a card reader. In my opinion, this option is *far* superior to the USB method because the camera itself doesn't have to be involved, eliminating extra wires and battery checking. You may already have a card reader built into your computer (built-in SD slots are quite common), in which case you are all set. Otherwise, you'll have to purchase an external card reader. These devices plug into (where else?) your computer's USB port, but unlike the bulky camera-to-computer connection, external card readers are quite simple to use. Once connected, your camera's card acts just like an ordinary hard drive or MP3 device as far as the computer is concerned. You just drag and drop your image files around to wherever you want them, just like any other file. External card readers are also inexpensive. You can find "all-in-one" external card readers from SanDisk and other companies that will read just about every format of digital camera card that exists, all for under twenty-five dollars.

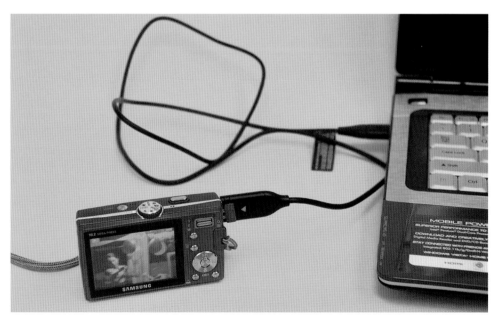

Here I've attached a point-and-shoot camera to my laptop using the USB cord provided with the camera. The thing I don't like about this system is the fact that you have to have both the computer and camera on and running at the same time.

Here's the simplest way to get your pictures onto the computer. I'm using my laptop's built-in SD card reader. This eliminates having to have the camera connected to the computer.

If you don't have a built-in card reader, you can always purchase an external model that is able to read just about any card style around, and at a very fast speed. One nice thing about external card readers is that they receive their power from the computer through the USB cord; they don't have to have their own power supply the way a camera does.

The Hard Drive of Doom

By now, Ron has quite a collection of images. He wants to get those images off the card, so he plugs his card into the reader, starts the transfer, and places all of his great pictures into a folder aptly named "Ron's Photos." Over time, he repeats this process again and again until "Ron's Photos" contains over two thousand images. This is fine for a while, until Ron is in a hurry for some reason and needs to find that picture from last summer of Bert with his dog . . . now where is it? Was it *before* the trip to Louisville or after? Wasn't it taken around July? Or was it June? Ron struggles for quite some time, wasting time that could have been used taking more

great pictures. Part of Ron's problem comes from the fact that all of his pictures are named things like IMG_93854.jpg, or IMG_93855. jpg, or IMG_93856.jpg, and so on, making it impossible to sort the images by name. Ron has created a Hard Drive of Doom.

But it doesn't have to be that way. First of all, Ron should create subfolders within his main "Ron's Photos" folder. One method would be to create a new subfolder for every month of the year. This keeps the pictures within each folder to a more manageable number. Alternatively, he could divide the folders up by topic, such as "So-and-So's Graduation," "Horse Pictures," "Lakes," "Portraits," or "Nighttime Photography

Experiments." More time could be saved by putting all of his favorite shots (those most likely to be used again at a later time) in a folder called "Ron's Best" or something similar. Next, he needs to rename his favorite images with file names that actually mean something. He should get rid of the IMG_##### file names and replace them with names like "Bert and his dog" or "Nice portrait of Violet."

All of this can be done without any special software, but things get a lot easier if you take advantage of a program that helps you organize your photos. Many digital cameras come bundled with some kind of simple photo software, one that often doubles as a photo organizer/editor. Unfortunately, these programs are often weak in their abilities and may not be much more than a basic picture viewer with some

kind of "album" feature to assist you in some general organizing. A better solution would be to invest in a more powerful photo program, and there are many of these available. Adobe Photoshop Elements is a popular editor/organizer for amateur photographers, but it comes at a price (about eighty dollars). Other more expensive—but highly powerful—options include Adobe's Photoshop Lightroom and Apple's Aperture software. (Visit www.adobe.com for information about student discounts on Adobe products.)

Back Me Up on This
So now, Ron has a nicely organized selection of images. They've been neatly put away into manageable folders, or perhaps sorted into order using some kind of photo software. Ron can now safely format his camera card

Once all of your pictures are off the card and onto the computer, you are left with the job of putting everything away. The last thing you want to do is let a mess build up like the one I've shown here, where hundreds of unorganized pictures are jumbled together in one folder.

and return to shooting, right? Wrong. He still needs to back up the photos that are now on his hard drive.

It's important to back up your photos so that you have identical copies of every photo in more than one place at the same time (for instance, one on your computer's main hard drive and another somewhere else). Then, in the event that some horrible disaster befalls one copy (say a clumsy friend who dumps soda directly into your hard drive), you still have the other set of pictures safely tucked away and ready to save the day. In a perfect world, you would try to maintain multiple copies, say three or four. In real life, the odds of more than one copy being destroyed or failing *at the same time* are pretty small, so I only worry about maintaining two copies of most of my photographs at one time.

How often you back up your photos depends on how much you shoot. If you only shoot a few pictures a day, then backing up every few weeks is fine, unless you get some kind of fantastic, once-in-a-lifetime photo. In this case, you should back up that picture as soon as possible.

Where do we put all these backup images? There are a few options, so let's run through them all.

Recordable CDs and DVDs

This is the most obvious method of backing up a large amount of data, like photo files. Many computers today have a recordable optical drive built into them, and if you're lucky enough to own one that does, you

It's important to back up your photos so that you have identical copies of every photo in more than one place at the same time (for instance, one on your computer's main hard drive and another somewhere else).

won't have to buy anything additional to back up your photos, except for the backup discs themselves. CDs are still a viable option but can only store about 650 MB of data. For this reason, I don't use CDs very often. However, if you usually work with smaller file sizes and only have to back up a reasonable number of photos, CDs could be a good—and inexpensive—option. DVDs hold more data (around 4.5 GB), so you can back up more images using fewer discs. This is a huge advantage. CDs and DVDs are fairly stable storage devices, but they can suffer from

Flash drives make great backup solutions, but you may find that they perform slowly when storing and retrieving your pictures. Naturally, the faster a flash drive performs, the more expensive it is.

External hard drives are my favorite method for storing and backing up my photos. I keep two identical versions of each drive at all times: one attached to the computer so I have access to my pictures, and the other put away in a safe place.

You have to examine your needs for space, speed, and convenience when determining what kind of backup solution is right for you. You also need to consider your budget.

various types of damage, the most obvious being scratches to the data (non-label) side. Always make sure that you keep all of your CDs and DVDs safely tucked away in their sleeves or jewel cases. From time to time, you may run across an occasional disc or two that simply refuses to be recorded on. This is common; just throw out the bad disc right away so that you don't get it confused with a good one.

Flash drives

USB flash drives make great backup solutions. These little guys can store quite a bit of data, and they come in various capacities. One potential problem with this option is that now your flash drive is filled up with pictures, leaving you little room for anything else. But flash drives are not very expensive, so you can buy several, the same way you would use multiple CDs or DVDs. Unfortunately, flash drives can be slow in saving and retrieving your images. In a pinch, your MP3 device (which is really just a fancy flash drive) can make a quick backup solution, although you may not want to leave the photos on there forever because then you can't store as many songs. (Even if your device does not have image-displaying capabilities, it can still be used to store any kind of data, not just music.)

External hard drives

If you want to go all-out and back up your photos with style, then purchase an external hard drive. These usually start at around seventy dollars and go up from there, and you can treat yourself to 500 GB, 750 GB, or even 1 terabyte (TB) or more of pure blank space with nothing to do but house your photos. These drives connect to your computer using a high-speed cable, either a USB 2.0 or a FireWire (IEEE1394). They are fast, have lots of space, and are very reliable.

The ultimate solution

The ultimate solution is to buy two external hard drives, both of the same model—one to store all of your original photos (the ones you are going to be working with) and one to store all of your backup copies. You are then free to remove all of your photos from the computer's main hard drive, freeing up tons of space that can be used for other things. This will also help in making your computer run more efficiently. Computers always run better when they have big empty hard drives to work with, so this is really the best option of all. What I like to do then is completely disconnect the backup drive from the computer and from the AC plug so I'm left with just the little box. This way, the backup drive can't become damaged by a power surge because it's not connected to anything. You could even keep the backup drive hidden away in a safe place whenever it's not in use. The other external drive can stay connected to your computer all the time so you have constant access to all of your wonderful pictures.

Having two external hard drives is the most expensive of all the backup options, but if you shoot lots of pictures and are serious about becoming a professional photographer, it is well worth it. On the other hand, if you don't shoot all that many photos, I wouldn't bother with this method; just back up with optical discs or flash drives and you'll be quite happy. In any case, if disaster ever strikes your computer, your pictures will be safe.

Working with Image-editing Software

Once you have your images downloaded and safely backed up and organized, it's time to do a little post-production work on your best images. While it is very possible and very admirable to shoot a perfect image right out of the camera, more often than not you find there are some little details that could be improved. If you enjoy working with RAW images, you'll find that quite often the RAWs look rather dull and lifeless straight out of the camera, so post-production work is an important step. JPEGs tend to start off with a little more punch and color, but they can still often benefit from some tasteful image editing. Let's cover some of the basic steps in image processing.

- **"Save As"!** If you make changes to an original photo, always use the Save As function to make a *copy* of the photo with any changes you've made to it. It's very easy to permanently destroy a good photo by saving a mistake to it, and sometimes you don't even know you've made an error until later. So always keep your original photos separate from the ones you are working on. Once you're positive that the changes you've made are for the better, you can delete the now-replaced original at leisure.

Be sure to use the Save As function when making changes to your photos. Delete the original version only when you're positive you like the new changes.

A small amount of increase to the exposure and saturation controls allowed me to improve a photo that was slightly dull (*top*) and come away with an image that is much closer to the way I really saw the scene (*bottom*). Be careful not to overdo things, though.

■ **Exposure.** Your image may be a little dark or a little light. If it's *too* bad either way, then you probably can't save the shot. Just say, "Oh well, that one got away," and move on; don't spend a huge amount of time trying to fix an image that is beyond repair, unless it was some incredible once-in-a-lifetime shot. If your image's exposure is only slightly off, try using tools like "Exposure" or "Blacks" to carefully brighten or darken the photo as needed. You can also try using the tools labeled "Brightness" and "Contrast," but I've found that these tools are usually too harsh. They darken or brighten photos more than needed. For the best results, search your software for a tool called the "Tone Curve." A little time spent experimenting with this tool will show you that it allows the photographer to brighten or darken *only certain areas of the photo.* This is extremely useful, because you can brighten a shadow without burning out any bright parts of the image. No matter which tool you use, try to watch your software's histogram to aid you in the process (see chapter 2 for a description of how a histogram works).

■ **Sharpening.** Your image-editing software may have a tool called "Sharpening" or "Sharpen" (or it may be called something like "Unsharp Mask"—it's all the same thing). The purpose of this tool is *not* to make a blurry image look sharper, but to help define and strengthen the edges and lines of a photo that is *already* acceptably sharp. For instance, a sharp photo of a rugged mountain or a building with straight lines will look even better when sharpening is applied to it, whereas a portrait or photo of a grassy field probably won't look much different. This is because sharpening works by finding straight lines in the photo and making them bolder. Now, that said, it is possible to take a photo that is a tad out of focus and use sharpening to make a more acceptable-looking print, but don't expect any miracles.

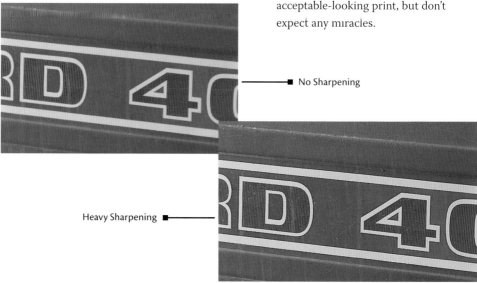

No Sharpening

Heavy Sharpening ■

Some photos—particularly those with lots of straight lines—need a little bit of digital sharpening to look their best. However, be very careful not to apply too much digital sharpening (*bottom*) because this can have a very degrading effect on your photos.

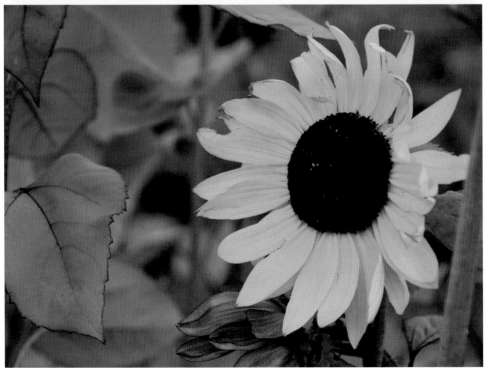

The original photo of this sunflower is nice but just a hair too dark (*top*). Again, I lightly used the exposure and saturation tools to enhance the finished picture (*bottom*).

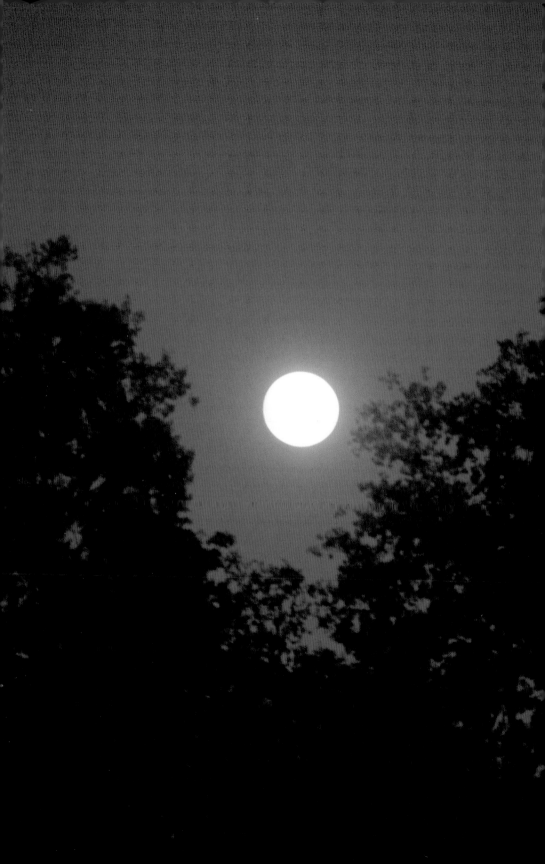

■**Saturation.** Sometimes the colors in your photos look a bit dull. In real life, you know those greens were greener and that sky was bluer than it appears on screen. If this is the case, use your software's saturation tool to boost the colors of the whole image. Just be careful: It's very easy to overdo saturation and end up with an image that has loud, garish colors. Over-saturation is one of the biggest signs of a beginner photographer who has gone overboard with post-processing. Aim to make the colors vivid but natural looking. (You can also *under*-saturate an image and take color away to create a faded look, or take away color altogether and create a black-and-white image.)

■**Where's the EXIF?** Every photo you take with a digital camera has a handy set of information bundled into it, known as exchangeable image file format (EXIF) data, which stores basics like the date the photo was taken, the time, which camera was used, which lens, and the camera settings. This can be helpful later on when you're looking over your photos on the computer and want to know which settings you used to get a particular shot. Look through the menus on your software to find out how to access the EXIF data for your shots.

Editing

Here's something to think about: The more images you have, the more time you will spend backing them up, and the more money

Opposite: At the time I took this picture, I got a little carried away and took three or four images that are almost identical. Rather than hold on to multiple versions of basically the same picture, I chose to keep only this: the best one.

you will spend on back-up media, whether it's blank CDs, DVDs, flash drives, or whatever. Obviously, I'm not going to recommend that you take fewer pictures, because shooting all the time and practicing as much as possible is the only way to excel as a photographer. But I do want you to consider throwing away any pictures that aren't up to par. You don't need to forever preserve and back up blurry, unflattering, poorly exposed, or otherwise failed photographs. Doing so will only waste disk space *and* your own time, because you will forever be skipping over these unnecessary photos on the way to finding the picture you're really looking for. So after you download a card, and before you back up the good stuff, take a few minutes to delete the photos that didn't work out as planned.

I Want Them All!

You may not like the idea of throwing away pictures. *Sure, one or two may be a bit fuzzy or a bit too dark, but otherwise, they are good pictures! Look at Bert's expression in that one! It's priceless! Who cares if it's a tad blurry?*

If this is the case, let me recommend a solution that will let you hang onto those "fun" pictures without clogging up your hard drive and backup media with poor photos. Chances are, even though you want to preserve these enchanting-but-less-than-ideal images, you probably won't be printing them at large sizes. If you try to make an 8×10 (or even a 5×7) of that slightly fuzzy one, it will look *very* fuzzy once it's blown up, believe me. So there is really no point in keeping a full-resolution TIFF or JPEG of something that will never be viewed except on a computer monitor or other screen, or as a small snapshot print. To save space (both on your main hard drive and on your backup device), consider creating a smaller

version of the photo by resizing the dimensions and applying a fair amount of JPEG compression to it. A picture that is already less than perfect (because it is maybe out of focus, or because of some exposure error) can usually stand more compression than one of your good photos. Use "Save As" to experiment with these settings until you have a copy of your original image that is of a smaller file size but still adequate quality for your purposes. Try reducing the

dimensions on the long side of the photo to around 2,000 pixels, and try using JPEG compression settings of 80 (on a scale of 1 to 100) or "Good Balance," or whatever similar settings your photo software may give you. You're looking for a compression setting that is slightly better than halfway between the worst and the best. Using these settings, I can take a high-quality JPEG image straight from my camera (normally a 5 MB file) and reduce it to around 500 KB, a significant

"Blurry but Cool!"

My brother Josh has some unique views on the topic of editing. His philosophy is "Never throw away anything." As a result, he keeps *every photo* he's ever taken—even images that are so bad that we don't even know what they *are* anymore. Josh files all of these photos in folders that are aptly named things like "Blurry but Cool" or "Miscellaneous Junk."

"You never know when I might *need* some of these," he says, as he files away another bizarre-looking image into his computer. Don't get me wrong. Josh is a great photographer, but he's also one of the few I know who fully embraces his errors and failed experiments. On the other hand, Josh got two of his "throwaway" shots published in this book, and I know other very well-known photographers who purposely shoot blurry "abstract art" photos that look just like these—and get them printed in national magazines regularly. So my advice is: You decide what to trash or not. Who knows? One person's out-of-focus smear is another person's art.

Josh Johnson

Josh Johnson

space savings. Again, I would never do this to a picture that I care about, but for those good/fun/weird/lousy images, this is a pretty good system.

Once you're satisfied that your new copy of the image is "good enough," back up this new copy and then say goodbye to your original.

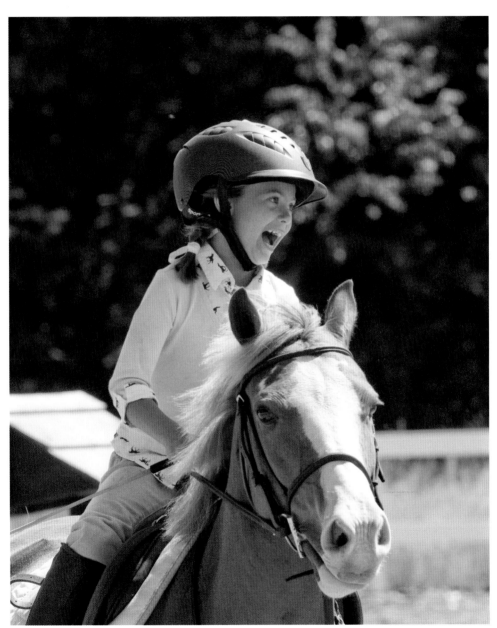

Unfortunately, this photo came out too dark; I accidentally underexposed it. I managed to recover the exposure with software, but doing this increased the image's noise. I don't like noise in my photos, but I'm willing to put up with it in this shot because the girl's expression is so good.

EXPOSURE: THE BIG THREE

IN THIS SECTION

All right, you've come a long way. It's time to get down to the nitty-gritty of how cameras really work to create fabulous digital photographs. In most photography handbooks, the information in this chapter is thrown at you right off the bat, but I thought it would be nice for you to learn how to handle a camera and compose pictures properly before being overwhelmed with these next topics, which can appear confusing at first. Just keep in mind during this chapter that these topics are only here to help you take *better* pictures. You can (and some people do) make wonderful pictures without knowing anything about these topics, but understanding them will give you more control over your photos. In the long run, you'll enjoy photography more if you learn and understand the Big Three: shutter speed, aperture, and ISO.

Everything in this photo is sharp, from the girl in the foreground all the way back to the big red barn in the background. This effect can be achieved by using Landscape mode or by setting your camera's aperture to a large f/ number like f/16 or f/22.

Shutter Speed

All cameras have a shutter (see chapter 1), which keeps the sensor hidden from any light until it's time to take a photo. When you press the shutter button, this curtain is lifted momentarily and then put back in place. But the exact length of time that the shutter is lifted has a huge effect on your photo. It's time to make shutter speed work for you, so check your manual and set your camera to the "Shutter Priority" mode. This mode is sometimes also known as "Tv" mode (for Time value), just plain "T" mode (for time), or "S" mode (for shutter).

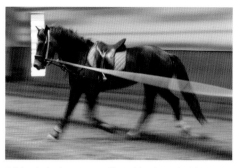

A friend of mine was working with a horse inside an arena when I happened to come by with a camera. Since it was far too dark inside to be able to freeze the horse's motion with a fast shutter speed, I decided to experiment with a short shutter speed of 1/15 instead. The resulting blurring effect conveys a strong sense of motion to the viewer.

Various Shutter Speeds and What They Can Do

Shutter speeds are usually written out as fractions, like this: 1/60, 1/90, 1/125, 1/180, 1/250, and many others. The fractions mean "one sixtieth of a second," or "one one-hundred-twenty-fifth of a second."

I used a shutter speed of 1/30 to help make these moving waves appear soft and sleek. I wasn't using a tripod, so I used image stabilization to help me hold the camera steady and keep the pebbles sharp.

I got up early one morning while it was still dark and went down by the road to take pictures of car headlights streaking by. I used an extremely short shutter speed of half a second to create this odd-looking picture. The body of the car was moving so fast that it doesn't even appear in the picture; all you can see are the streaking headlights and taillights.

You might also run into a shutter speed that is not a fraction, like one second or two seconds, but these are only used in very dim conditions or some other special-effect situation where you need to let in a lot of light. For now, let's just look at the more common shutter speeds and what they do.

The first thing you need to know is that the fractions really don't mean anything important to us. Forget all about the "1/" part of it, all you need to care about is the second number—the larger number—like 60, 90, 125, 180, 250, and others. (This is probably how the shutter speed is displayed in your viewfinder anyway.)

We care the most about the shutter's ability to freeze or smear moving objects, even if the object is not traveling fast. The lower the shutter speed number, the less ability it has to freeze a moving object.

- **15 and lower:** Very long shutter speed. This cannot be handheld without creating camera shake, even with image stabilization (see chapter 2, in the section "Image Stabilization"). The slightest motion will be blurred with this shutter speed; rustling leaves will become blobs, a person turning his head or laughing will create a faceless smear. Moving water can be very beautiful at these speeds.

- **30:** Slightly faster but still prone to camera shake; image stabilization may be able to keep the camera steady. Objects that are moving at any significant speed will appear totally blurry.

- **60:** The lowest shutter speed that you can handhold successfully without aid. Most portraits can be obtained at this speed if the subject remains reasonably still.

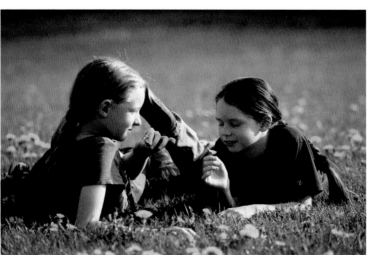

An average shutter speed of about 1/125 or 1/250 is all that is required for most normal shots where the action is slow. I used a narrow depth of field and a good background for this spring photo of two girls sniffing wildflowers.

This picture was taken inside a barn, with just a small shaft of early morning light coming through a crack. I had to wait for the horse to stand very still so that I could use the required shutter speed of 1/30. Image stabilization helped keep him sharp, while the slow shutter speed helped to give his cloud of breath even more swirling motion.

■**125:** An average length of shutter speed. People and animals walking will be sharp. People or animals running will probably be blurry but not terribly blurry. You can handhold 125 with confidence.

■**250:** Right on the edge of keeping every moving object sharp. Only objects that are traveling quite rapidly will be blurry. A galloping horse will have a sharp body and head, but his

A shutter speed of 1/500 was used here. Notice how 1/500 is fast enough to freeze the motion of the toy helicopter's body but not its spinning blades. This is because the blades are moving much faster than the helicopter's body. If I had wanted to freeze the blades too, I probably would have needed to use a shutter speed of 1/2,000 or more.

Again, a shutter speed of 1/500 is good enough to freeze almost all the motion, but not quite. The horses, their harnesses, and even the bits of flying dirt are all sharp, but notice how the horses' front legs show just a little bit of motion blur.

legs (which are moving faster than his body) will probably be slightly blurred. This can be a beautiful effect. You can handhold 250 all day long without a care.

- **500:** Almost everything is sharp. Laughing people, running people, clapping people, and jumping people will probably all be frozen in perfect sharpness.

- **1,000:** You can stop a train with 1,000 and still see clearly enough to count bolts on the spinning wheels. Almost

everything shot at 1,000 is motionless. The detail captured in fast-moving objects will be pristine.

- **Anything over 1,000:** You probably won't be able to see any difference in photos taken at 1,000, 2,000, or 4,000: They will all be sharp. The only time these extremely high speeds come in handy is if you happen to photograph very close to a very fast-moving object like a hovering hummingbird's wings. Anything over 4,000 would be useful

With a shutter speed of 1/750, this flying honeybee's body is frozen in perfect stillness, except for the wings. A much higher shutter-speed number would be required to freeze the wings.

This bird was flying past me very quickly, but my camera's autofocus was able to lock on successfully. I used a shutter speed of 1/6,000 to freeze every detail of the sunlight coming through his wing feathers.

for . . . I don't even know. Maybe freezing a bullet. Otherwise, 500 and 1,000 are good enough for most moving subjects that you'll encounter.

Shooting with a shutter speed of 1/1,000, I was able to capture every detail of this running foal in perfect sharpness. The big, open field also made a great background, with no distracting elements to compete with the main subject.

These are only *guidelines*, however. The direction an object is moving can have a big effect on how fast you should set your shutter speed in order to prevent (or cause) blurring. For instance, objects traveling toward (or away) from the camera can be frozen with a slower shutter speed than objects traveling straight across the camera's field of view. Compare this to riding in a car going down the highway at a fast pace. Objects out in front of the car, like signs and trees, appear sharp and clear, even though you and the car are moving quickly toward them. But if you roll down a window and look straight down at the road beneath you, it's impossible to see any detail at all; the whole thing is a blurry mess.

For this picture, I used the panning technique to keep the moving horses sharp while allowing the background and foreground to convey a sense of motion.

Moving Objects

So, let's say you're going to photograph some action. If you set your camera to Sports mode (find the little button with the picture of the man skiing or running), then your camera will do its best to select a high shutter speed like 750 or 1,000. Alternatively, you could use Shutter Priority mode to dial in a high number on your own. This way, the moving object—whatever it is—will be frozen with sharp details. Excellent. But sometimes you don't necessarily *want* your subject to be frozen. Sometimes it's interesting to play around with making moving objects appear streaky and blurry on purpose, in an artful way. To do this, take your camera off Sports mode and select a slower shutter speed. Experiment with 125, 60, 30, and even 15, depending on just how fast the subject is moving. Of course you will get some

> Sometimes you don't necessarily *want* your subject to be frozen. Sometimes it's interesting to play around with making moving objects appear streaky and blurry on purpose, in an artful way.

unusable pictures this way, but if you keep trying, you may be pleasantly surprised at some of the results you achieve.

No matter which style you're after—streaky motion or tack-sharp detail—you should always pan along with any moving object. You do this the same way you might use a video camera: You steadily and carefully follow along with the moving subject, keeping it in the same place in your

viewfinder at all times. This method ensures that you're shooting the best possible images. Panning is much easier when you're using an optical viewfinder rather than an LCD screen, so DSLRs have a big advantage in shooting action photos.

If you'd like to try an interesting but difficult technique, pan along with a moving object and use a slow shutter speed, like 60 or 30. If you can manage to pan your camera at exactly the same speed as the moving subject, your picture will end up with a sharp subject but a streaking background that suggests a sense of speed and movement. Very clever, and always a crowd pleaser.

Aperture

Inside every lens is a little device known as an aperture, which controls how much light gets through the lens. The aperture is basically a little hole that can be adjusted to different sizes: big to let in lots of light, or small to let in a small amount of light. Photographers describe how big or small this hole is by using the term "f/stop." (Remember exposure compensation from chapter 2, and how each +1 or +2 was worth one stop? These are the same stops.) These f/stops come in various numbers like f/4, f/5.6, f/8, f/11, and f/22, plus lots of others. Forget about the "f/" part of it; we don't have to remember that. All you need to look at is the number. The *smaller* the number, the *more* light enters the camera. The *higher* the number, the *less* light enters the camera. It may seem like the opposite of common sense, but that's how it works. An f/stop of f/4 lets in more light than an f/stop of f/11.

What good is all this? Who cares how much light gets to the camera? Well, the shutter speed cares—a lot. Here's why. Using a short shutter speed (like 1,000) that can freeze moving objects comes with a price: Very little light reaches the sensor this way.

I brought the camera down very close to the ground for this picture so I could show all of the fallen leaves. Then I used aperture priority mode to select f/11. This gave me the wide depth of field I wanted for this shot.

To achieve the frozen-motion look, the shutter only lets the sensor look at the object for the slightest instant (1/1,000 of a second). It just opens quickly and closes. If we left things alone, the picture would be too dark to see because there wouldn't be enough light coming through the shutter in that short time. For the photo to succeed, extra light must come from some place. That place is the aperture. To use a higher shutter speed number, the aperture must be set to a lower number, such as f/2.8 or f/4, to let in more light. The opposite is usually true if you're after a long shutter speed like 30—tons of light is coming through the shutter, and if it isn't held back, the photo will be too bright. The aperture can come to the rescue again by restricting the light with a hole size of f/16 or more. (Remember, the bigger f/ number means LESS light entering the camera.) Exposure is always a balancing act: For one thing to be gained, something else must be sacrificed.

Quick Fact:
Your Eyes Are Like a Camera

Have you ever noticed how everything looks dark when you first come inside after being outdoors on a bright, sunny day? It's because your eyes' pupils behave rather like a camera's aperture: When things are bright, your pupils close down to stop all that extra light from pouring in. Likewise, if you're outside at night or working in a dark room, your pupils open up to capture more light and make things easier to see. This is exactly the same principle your camera lens uses. (For those interested, your eyes function at a "shutter speed," so to speak, of about 1/30.)

Now, sometimes we don't care much about the shutter speed. If you're shooting a normal portrait, a photo of a building, a landscape, or many other photos with no motion in them, the shutter speed isn't a big concern. Any old average speed will suffice. On the other hand, you might care a great deal about what aperture is used because your lens' aperture plays another huge role in photography: control of depth of field.

Depth of Field

Depth of field is a term used to describe how much of a photograph is acceptably sharp. Okay, it's like this: Ron takes a picture of his dog. The dog is his subject, and since the dog's face is a very important part of the dog, Ron focuses on his dog's eyes. We know the eyes are going to be in focus, but what about the rest of the subject and the environment around it? How much of these areas will be sharp? It depends on the depth of field, which can be controlled to a large extent by choosing the proper aperture for a particular photo. Three different things can happen to the depth of field on Ron's dog picture:

- **The depth of field can be very shallow**, so that only the dog's eyes are in sharp focus. Everything behind the eyes—like the dog's body and the whole background—will be blurred. Everything in front of the eyes will also be blurry, like the end of the dog's nose. To do this, you need a very wide aperture (a very small f/ number), such as f/2.8.

- **The depth of field can be reasonably shallow**, so that the dog's entire face and most of his body are in sharp focus, but the background is pleasingly blurred to keep the viewer's attention focused on the dog. The end of the dog's nose will be sharp too. This effect might be achieved with a midrange f/ number, such as f/4, f/5.6, or f/8.

I did three things here to create the very shallow depth of field I desired. First, I used my lens' smallest f/ number, f/2.8. Then I zoomed my lens out as far as it would go (200mm) and moved myself in very close so I was positioned only a few feet away from the garden glove and fence. The result is a tack-sharp glove with a wonderful creamy-green background.

■ **The depth of field can be wide**, so that *everything* is sharp, from the end of the dog's nose all the way to the mountain in the distance. (Be careful, Ron, not to include something distracting or unattractive in that background!) This would require a large f/ number (a small hole) like f/11, f/16, or f/22.

There are three other factors that affect depth of field: lens focal length, camera-to-subject distance, and sensor size. Bigger sensors (like those in DSLRs) and longer focal lengths have an easier time creating a shallow depth of field than smaller sensors (like those in point-and-shoot cameras) and wide-angle focal lengths, which are better at creating photos with a large depth of field. Depth of field also decreases the closer you are to your subject and increases as you move farther away.

The aperture is basically a little hole that can be adjusted to different sizes: big to let in lots of light, or small to let in a small amount of light.

Setting the Aperture

To take control of your lens' aperture, set your camera to Aperture Priority mode, also known as "A" mode (for aperture, but check your manual first; A could also mean AUTO) or "Av" mode (for aperture value). The camera will then allow you to turn a dial or press a combination of buttons to select various apertures.

This shot was achieved using settings similar to the garden glove picture (*page 121*) but with the added bonus of some nice golden hour light. This is just one blade of grass in a whole field, but every other blade has been lost in the shallow depth of field.

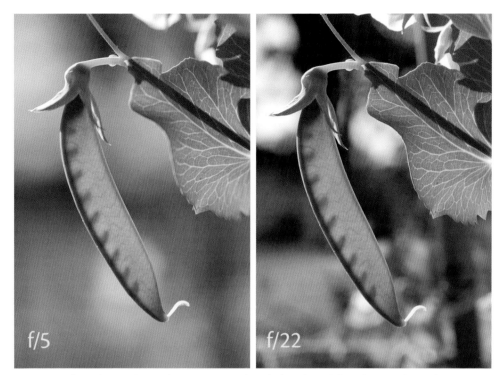

Here are two identical images that I took moments apart. The only thing that is different between them is the aperture setting. In the first picture, I used an f/stop of f/5. In the second picture, I used f/22. Notice how f/22's wider depth of field made for a less attractive image, with more distracting colors and objects, while f/5 is very clean and pleasing.

ISO: A Way to Have It All

What if you want to use a wide depth of field (like f/11) *and* a fast shutter speed (like 1,000)? Putting these two together means that very little light is getting to the camera because it is first blocked by the aperture, and then what little light does get through f/11 is restricted further by only touching the sensor for 1/1,000 of a second. So unless you are shooting in very bright conditions, the answer is: You can't; the picture will be too dark. That extra light has to come from somewhere, so one of them (either the aperture or shutter speed) is going to have to give.

That is, unless you adjust your ISO.

One last solution exists to save pictures that will otherwise be too dark, and that is to raise the actual sensitivity of the camera's sensor. If the sensor can be made to be satisfied with less light to begin with, it gives photographers more flexibility in choosing their apertures and shutter speeds. A sensor's sensitivity (boy, there's an interesting phrase) is known as its ISO (International Organization for Standards) setting. As is the case with shutter speed and aperture numbers, ISO settings are measured in stops (or EVs): 100, 200, 400, 800, 1600, and others. A low ISO number, like 100, is not very sensitive. It takes a lot of light to satisfy ISO 100. Likewise, ISO 1600 can seem to make a photo out of nothing; it's *very* sensitive. If you wanted to shoot a picture of a moving object at 1/1,000 with an f/stop of f/11 (to achieve a wide depth of field), you could probably make the picture work by boosting the camera's ISO setting to 800 or 1600, and everything would be great.

For this shot, I knew I would need a very high shutter speed to capture the motion of the running dogs. But I also wanted a wide depth of field, and that demanded the use of f/8. Putting these two settings together meant that very little light would reach the camera sensor, so I was forced to use a higher ISO setting than I normally do. By the time the dogs came running up, I had all my settings prepared and was ready to capture the action.

Except . . . like everything else in photography, gaining in one way costs you in another. In the case of a high ISO number, you gain sensitivity but lose quality. High ISO numbers can make the photograph come out with lots of noise (little colored specks all over the photo; see chapter 1) because the camera is trying to make a picture with light that just isn't really there. The tones of the photo may come out more or less correct, but most detail and even some of the colors will be lost. So using a high ISO number gives you flexibility in some ways, but you pay for this flexibility by losing image quality. Photographers always want to maintain the highest possible quality in their photos; that's why we shoot at the highest camera quality settings, that's why we buy good lenses, and that's why we use low ISO numbers (100, 200, 400) for everyday work. High ISO numbers (especially those over 800) should only be used for unique situations. It's almost always better to lose a little depth of field at f/4 than to lose quality by using ISO 1600. (Note: This tradeoff is true mainly for everyday point-and-shoot cameras and most lower-end DSLRs. Some top-quality, professional DSLRs can handle high ISO numbers very well.)

QUIET! I'm Trying to Photograph!

Working with a high ISO can be quite convenient, so camera makers and photographers have tried to come up with better ways to eliminate noise. One way is to increase the size of the camera sensor because a larger sensor creates less noise than a smaller one. The problem here is that big sensors are expensive, so currently they are only built into high-end, pro-quality cameras. A simpler way to keep the noise down is to apply a kind of software trick to the image after exposure. Such techniques are known

I Can See the Light!

High ISO numbers aren't the only noisemakers: Long shutter speeds can be noisy too. This is one of digital photography's shortfalls but one that camera manufacturers are working to improve. For example, consider a photo of a night scene with stars. The photographer probably needs to use a very long shutter speed—maybe in the range of twenty or thirty seconds—to gather enough light to make the image. The entire time that this long-exposure photo is being made, the sensor is busy trying to find any scrap of light it can to add to the photo. The problem is that the sensor itself—because it is an electronic device—creates a kind of interference, a kind of electronic hiss that it then mistakes as light. It's as if the sensor were talking to itself and then asked, startled, "Who said that?" The sensor is trying so hard to see light, it starts making things up! These errors create the little colored specks and grain that are known as noise.

as *noise reduction*. Noise reduction can be applied by some cameras right after the image is taken (some cameras will do this automatically if the exposure is particularly long or if the ISO is over a certain number, such as 800) or later by the photographer using photo-editing software. If you choose the latter route, just be careful. Applying *too* much noise reduction can have a degrading effect on the photo; the software is trying so hard to smooth away the bits of color that it ends up smoothing away parts of the picture that aren't noise and can create a blurry/dreamy/metallic-looking photo out of a nice, sharp one.

Taking Control

If your camera offers a manual exposure mode ("M"), you can use it to take complete control over all three aspects of exposure at once: aperture, shutter speed, and ISO.

Experimenting with this can be fun, but it is difficult and time-consuming to do properly. The camera will still try to help you out by using the exposure compensation graph to warn you if it thinks your settings are incorrect. If it blinks -1 or -2 or more, then your current settings are probably going to make the picture come out to dark. If it blinks +1 or +2 or more, your picture will probably

The "Sunny 16" Rule

Find any old photography book in a library or at a garage sale, and you will almost certainly find mention of the "Sunny 16" rule. This is supposed to be a "simple" way of figuring a correct exposure in the event that your light meter fails. The idea is that on a bright, sunny day, when photographing a subject in direct sunlight, with your aperture set to f/16, your shutter speed should be set to a number approximately equal to that of your ISO rating. Huh? What in the world is that supposed to mean? It means that if you're shooting at ISO 100, your shutter speed would traditionally be set to 1/125 of a second, with an aperture of f/16, on a sunny day. Usually, none of this matters because you have your light meter to rely on. But if you happened to be climbing a mountain in a remote country far from a photo store and your light meter suddenly died just as the sun came out to light up the most incredible view ever seen to man—then the Sunny 16 rule just might be able to save your day.

be too light. Of course, the whole point of manual mode is to get away from what the camera thinks is right, so you can ignore its warnings and try out your own ideas instead. If you are interested in trying manual mode, be sure to experiment with it first in a controlled setting with pictures that aren't important, until you get the hang of it.

TIPS FOR SPECIFIC TYPES OF PHOTOGRAPHY

Sometimes the best people pictures come from the times when there is no setup and you simply capture people doing their everyday tasks. The simple green background of this picture helps the subject and buckets stand out.

B y now, we've looked at lots of photo tips and techniques that are helpful for general photography, so now let's have a look at ways to apply what we've learned to some specific situations. Always remember to keep an open mind and feel free to experiment with your own ideas as well. There are no hard and fast rules to any of these topics, only guidelines.

I used a very wide-angle focal length for this landscape to take in a large area of field, trees, and sky. Using such a wide focal length automatically gave me a wide depth of field. Everything is sharp.

Landscape Photography

Landscape photography includes any photo that has an outdoor scene for its main subject, whether it's a mountain, grassy field, desert vista, shoreline, seascape, or any number of other similar scenes. The scene may be all natural, or it may include a manmade object, such as a fence, barn, building, city skyline, boat, or road.

- **Choice of lenses.** Just about any lens can be used for landscape photography, but you will want to use certain focal lengths to achieve certain objectives. For instance, wide-angle lenses are the most popular landscape lenses because they can take in a huge sweeping view of the area. Sometimes this looks great, but sometimes you might want to try a slightly longer lens in order to draw emphasis to a particular area of interest in the scene. Some photographers will even use a very long telephoto lens in order to create a dramatic look or to make the sun or moon appear larger in the photo than it normally would. Experiment with different focal lengths to see what style you like the best for your landscapes.

- **Extreme depth of field.** The best landscape photos have a depth of field that is very wide. *Everything* is perfectly sharp. You can achieve this with your own photos quite easily by using Landscape mode or Aperture Priority mode to dial in an f/stop of around f/11, f/16, or even f/22. Doing this, if you'll recall, has an effect on your shutter speed; because f/16 restricts the light from coming through the lens, the shutter must stay open longer than usual to compensate. On most subjects, this is undesirable because the subject

I used a short telephoto focal length of 125mm for this fall scene of a river and trees. Using a wide focal length would have included too many trees and taken emphasis away from the water.

may move and blur the image, but most landscapes don't move around very much. The only thing you'll want to avoid is camera shake, and this is where a good tripod comes in handy. Most landscape photographers would never be caught out in the field without their tripods for this exact reason: They always want to be able to create a sharp photo with a wide depth of field.

- **Lighting.** Lighting has a huge effect on your landscape photography. As is the case with any other subject, good lighting can make or break a picture, but perfect lighting in a landscape is of particular importance. Weather plays a big part in landscape photography, not only because it has such a dramatic effect on lighting, but because interesting clouds or sky

colors can improve a photo that would otherwise be dull and turn it into a winning image. However, it would be rare for you simply to stumble upon a perfect landscape and have the lighting and weather be perfect at the same time (although it can happen). Instead, you might want to try scouting for landscapes whenever you can and

Weather plays a big part in landscape photography, not only because it has such a dramatic effect on lighting, but because interesting clouds or sky colors can improve a photo that would otherwise be dull and turn it into a winning image.

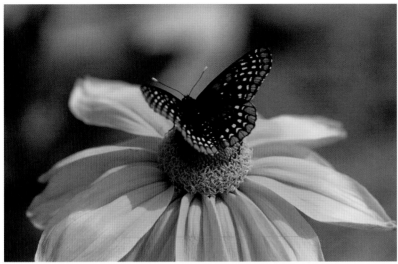

Shooting macro images of moving objects like butterflies is difficult but not impossible. Try to follow the butterfly around until it finds a particular flower that it seems to enjoy and then quickly take the pictures before it leaves for another flower.

then observe them over a few days or even a few weeks to see how different times of the day and different weather patterns affect the landscape. Where does the sun come up? Where does it go down? When does the light hit that tree (or that mountain, or that field, or that lake) just perfectly? Once you've determined this information, you'll know exactly when to head out with your equipment to get the perfect shot.

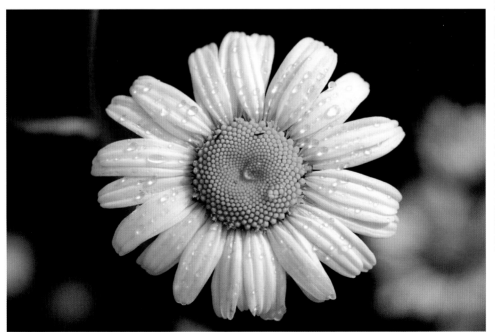

I went out early one morning with a macro lens to take pictures of dewdrops on flowers. Whenever you can, try to find dew or rain droplets on subjects that you want to photograph up close. This usually adds interest to the photo.

Macro Photography

Macro photography refers to working up close, usually with small subjects or small pieces of a subject. Insects and flowers are the most common subjects of macro photography, although it can also be used for specialty subjects like coins, stamps, and other collectible items. Macro photography can also be used to take pictures of a small feature of a subject, like a close-up of someone's eye or the hood ornament of an old car. No matter what the subject, macro photography means you are getting in very close.

Choice of Lenses

If you're working with a point-and-shoot camera, you're probably in pretty good shape to try macro photography. Most point and shoot models offer a macro

mode that generally does a decent job of making the lens focus closely on the subject. Be aware that in order to succeed, you'll need to zoom the lens *out* as far as it can go. Do *not* zoom in, or you won't be able to focus closely. If you use a DSLR, you will need a dedicated macro lens (sometimes called a micro lens) to get the best close-up results. For our purposes, the terms "macro photography" and "micro photography" are interchangeable. *Micro* means "small"; *macro* means "large" (i.e., photography that makes small things look large). These lenses are designed specifically for close-up work and can focus very closely with ease. They are also rather expensive, so if you don't have one or can't get one, experiment with the lenses you do have and see how close they will allow you to focus. Unlike a point-and-shoot camera, a short telephoto lens on a DSLR gives better results than a wide-angle lens.

It's Blurry!

The biggest challenge of macro photography is achieving a sharp photo. To begin with, it can be difficult to hold the camera sufficiently steady when you are very close to a subject. There are two reasons for this. One is that a macro lens works kind of like a telephoto lens (only in the opposite direction), making it hard to handhold the camera. The other reason is that a macro lens gives you an extremely shallow depth of field. Once you get in close, you may find that it is difficult to get everything in the photo acceptably sharp at the same time. You can increase your depth of field by using a small f/stop number (like f/22), but even this may not fix the problem completely, and you might run into trouble with blur caused by the resulting low shutter speed. One thing you can do to help in this situation is to decide what the focal point of your photo should be. If the subject is an insect, the most important part (and the one that needs to be the sharpest) might be the head, or the

Here's an interesting macro look at some colorful chalk pieces. Look at all the tiny texture details that become visible when you get close. A whole new world awaits those who take up macro photography.

This is a building where electricity is created from the river water passing underneath it. Shooting from a boat, I used the strong horizontal lines and a wide depth of field to make the building seem to stretch out into the distance.

wings, or any interesting color pattern on the insect's back. If the subject is a flower, you might choose to focus on one or two petals or the colorful center of the flower. If you are using a DSLR, you may find it easier to disable autofocusing and take over manually. Then you can manually set the lens to its closest focusing distance and simply move your body in and out to find the focus. Because the depth of field is so small, even the slightest forward or backward movement of your body will throw different parts of the subject into sharp focus. You can also use a tripod to keep everything steady, but you may find it quite challenging to maneuver a tripod-mounted camera into the right position for macro work. Another way to increase your depth of field is to avoid getting in *too* close to your subject to begin with.

Quick Tip:
It's All in the Details

One thing that is fun to do (and makes great pictures) is to concentrate on taking pictures of smaller items around or in the building, in addition to trying to get the entire building or room in one shot. These detail shots are great storytellers and add an interesting and fresh perspective to your collection of architectural photos.

Architectural Photography

Taking pictures of buildings (both inside and out) can be difficult to do well. This is because as soon as you get close to a building, you have to zoom out or use a wide-angle lens to fit in the whole building. And once you do that, you risk distorting all the straight lines that make up the building. Wide-angle focal lengths make straight lines look bent and weird (especially near the edges of the photo). Outdoors, the problem can sometimes be fixed if you can get far enough away from the building to zoom in a bit and apply a short telephoto look to the picture. This takes away all the distortion. But this isn't so easy to do on interior shots. For those, you must concentrate on keeping straight lines (like corners) away from the extreme edges of the frame, if possible.

Professional architectural photographers solve all these problems by using large-format film cameras, known as view cameras. View cameras are flexible and can be bent in all kinds of ways that small cameras can't, and this bending can eliminate the distortion effect.

People Portraits

Everyone likes to take pictures of people. Taking *good* pictures of people can be a challenge, although a fun one. Here are a few tips to keep in mind the next time you shoot people portraits.

"Back up, zoom in!"

This is the most important piece of advice I can give any portrait photographer. The worst thing you can do when photographing people is to use a wide-angle lens or to have your point-and-shoot camera zoomed out all the way. There are two reasons this is a bad idea. First, wide-angle lenses create a bit of distortion. While this effect might be

I was able to photograph the interior of this building with a very wide-angle lens and still avoid distortion because it was a rather round building. Notice how the windows are actually overexposed; I had to do that in order to make the main body of the image come out correctly.

This portrait was shot very close to the subjects using a wide-angle focal length. The problem with this technique is that there is not enough emphasis on the subjects, and the wide focal length creates some distortion on their faces.

unnoticeable in a landscape photo, it does awful things to people's faces, stretching cheeks and making heads, noses, and ears look too big. The ultimate example of this is when someone holds a point-and-shoot camera (or a cell phone) out at arm's length and points the lens backward at him or herself. Have a friend step back a few feet, zoom in, and take the picture for you.

Another reason that wide angles and people don't mix is that the wide view generally gives too much area around the subject(s). When taking pictures of people, always remember that the person is the subject, and be careful to eliminate as much of the background as possible. To achieve this, remember to "back up, zoom in." Stay at least six feet away from your subject and use a focal length of at least 80mm, if not longer. Work backward, so to speak, by setting your lens to the right focal length first and then moving yourself around into the right spot instead of

setting the focal length based on your position. This does a few things. It eliminates the distortion effect and makes people's features look closer to reality; it helps you achieve a more shallow depth of field, which always makes for a more pleasing portrait; and it helps you fill the frame with your subject's face and shoulders.

Shoot a lot of pictures

People blink. People make odd faces, even when they don't mean to. People look cranky, even when they're not. And the more people you have in a picture, the more chances there

> When taking pictures of people,
> always remember that
> the person is the subject,
> and be careful to eliminate
> as much of the background as possible.

are for someone to have an odd expression at the moment a photo is snapped. Your best bet is simply to shoot a lot of pictures and fairly quickly.

Don't tell people to smile

Telling people to "Say cheese!" doesn't usually work. The subjects simply grin, and everybody looks unnatural. The smiles don't look real. Likewise, don't say things like, "I'm going to take a picture. Hold still!" This makes people look stiff and uncomfortable. People don't need to hold still; it's far better if they're relaxed. As I've explained, as long as you're shooting with a shutter speed of 1/125 or 1/250 or higher, virtually all subject movement is frozen. Let people just be themselves, and your photographs will take on a whole new feel. Then, once someone has a nice expression, don't say, "Hold it right there! That was perfect!" The minute someone

tries to hold what had been a natural look, it looks fake and stiff. Just let the camera capture the perfect moment for you.

The Problem Is . . .

Most people are used to standing rigid and smiling stiffly when having their picture taken. They expect you (the photographer) to want that, and it can be very hard to explain what you *do* want. My best advice here is to go ahead and take the picture a few times while they stand there rigidly and grin. These are digital pictures, after all, and they don't cost anything to take. After you've made these first images, start trying to help your subject relax. Take the camera away from your face and ask a question or two. Fiddle with some dial on your camera, as if you're getting ready to try something else. Doing these things takes the pressure of being photographed off of your subject, and as soon as the pressure is off, people

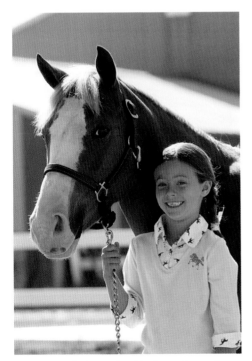

As I photographed this girl and her horse, I first took some posed, formal portraits with their attention on me.

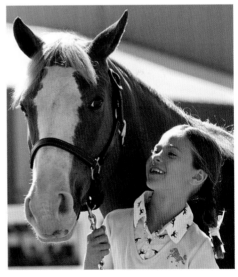

After a few minutes of formal portraits, I asked the girl to try talking to her horse instead of smiling at the camera. This gave me a different look. Now the girl is laughing with her horse, and his attention (notice his ear position) is focused on her. Both portraits are nice, but I prefer this one.

> **Take pictures while your subject talks and while they laugh. Tell them to look out the window (people sometimes relax more if they aren't staring into a lens), ask them about their hobbies, or their dog, or favorite books. After a short time, your subject will most likely be comfortable with you and the camera, and you'll start to get really good images.**

start to relax and look more natural. While still maintaining the conversation (although it can be tough to shoot and talk at the same time!), bring the camera back to your eye and continue taking pictures. Just keep talking, shooting, talking, shooting, and occasionally adjusting the camera. Take pictures while your subject talks and while they laugh. Tell them to look out the window (people sometimes relax more if they aren't staring into a lens), ask them about their hobbies, or their dog, or favorite books. After a short time, your subject will most likely be comfortable with you and the camera, and you'll start to get really good images.

Lighting

Good portraits require good lighting. One of the best things you can do is to turn off your camera's flash (or only use its fill-flash mode). This eliminates any red-eye problems and keeps your portraits looking natural instead of "flashed." Portraits shot in natural light tend to have a pleasing look. Indoors, try using window light, particularly on windows facing away from the sun, so your subject is lit with soft, reflected light. Outdoors, cloudy days are wonderful for people. "Golden hour"

light is pretty, but it can be difficult to use with people because they have to squint when facing the light. To beat this, try having your subject face slightly away from the sun so his or her face is illuminated with side lighting. Sunny middays should be avoided if possible, but one great trick is to have your subject face completely away from the sun (so the subject's face is shaded by his or her own head), and then shoot a tight face portrait

The Best Way of All

Formal portraits are fine, when you have the opportunity to set up your subject in a nice location, but I find the pictures can sometimes turn out dull and lifeless. My favorite way of taking people pictures is with a semi-candid approach. To work like this, you simply have your camera around but don't make a big deal over the fact that you have it. Don't say to everyone, "I'm going to be taking pictures!" Just take your camera out of the bag and casually start shooting, but don't try to disguise the fact either. What ends up happening is that people are aware you have the camera but aren't particularly thinking about themselves being photographed. The results are great-looking *natural* portraits of people doing what they really do, not just standing with a frozen grin gazing at the camera. Photograph the kids playing with the dog; photograph the dads standing around the car and whatever else is happening.

Animal Photography

Taking good pictures of animals requires patience and a good sense of humor. If you are trying to get pictures of wild animals (like deer, birds, squirrels, bears, etc.), the best thing to do is work slowly and quietly and use the longest focal length you have available. Some wild animals are most likely to be seen right around dusk, so you might try raising

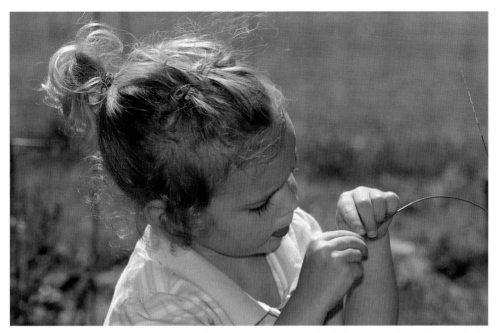

Always be ready to capture the quiet moments, when people aren't concerned with the process of being photographed. Natural moments in between formal shots can be very nice. I used a fill flash here to eliminate some of the midday shadows.

It was late autumn, just before winter, when this chipmunk decided to brave the heights of a crabapple tree to collect some of the fruit. He was about ten feet off the ground and seemed to take no notice of me as I captured shot after shot.

your ISO considerably if you're going to be shooting at that time. It's better to have a little noise in your photo because of a high ISO number than to risk having the animal appear blurry because your shutter speed was too slow. If you set up a feeder at a location not far from your house, it can work very well for attracting wildlife to come within range of your camera. If you hang a bird feeder right outside a window, you might not even have to leave the house. Just keep a camera nearby, ready for action whenever it appears.

Pet photography is something else entirely. We don't have any trouble getting close to pets; they're often *too* close. For small animals like dogs, cats, rabbits, and so on, you want to get down low so that you and the camera are at eye level. Like people portraits, animal portraits look best when shot with a focal length of around 80mm to 150mm. For action pictures and candid pet shots, just follow the animal around and be ready to

Getting close enough to wild animals for a good photo can be difficult, but it's not impossible. Knowing all you can about your chosen subject's habits and lifestyle helps significantly. Always exercise caution whenever you are photographing wild animals.

You will often be able to achieve nice pictures if you put people and their pets together in a photo. Multiple subjects are always fun to work with, and you have the added advantage of the interaction between the person and the animal.

snap pictures whenever things get interesting. For portraits, you'll probably need some help from a friend (or the pet owner) to keep the animal in place. The problem with this is that the pet may keep its attention on the nearby handler instead of on you. To avoid this problem, experiment with making some funny sounds, like whistles or whines or kissing noises, to get the animal to put on an interested expression and look at you and your camera. Holding treats and favorite toys might also do the trick.

Always be prepared for the unexpected when photographing animals. Usually you don't have the opportunity to re-create a unique situation, so you will always have to be ready for that one perfect shot.

For larger animals like horses, cows, llamas, and others, you can use the same techniques, except that you may have less control. Try following the animal around its environment for candid pictures or ask the owner to pose the animal for a more formal portrait. Again, interesting noises can help get good expressions. For horses in particular, try having a helper make some kind of intriguing noise behind you, such as shaking a handful of hay or rattling a grain bucket. You're almost guaranteed to get a good expression this way. Larger animals look best when photographed with a focal length of 150mm or more.

Still-life Photography

Still-life photography usually refers to an attractive arrangement of nonmoving objects. Often, the photographer will take much more time setting up the exact composition, placement of items, and lighting than he will actually take taking the photos. Flower and food arrangements are popular still-life subjects, but you can try any subject you wish. Still life can include one item or dozens of items; there are no rules. If you do choose to include multiple objects, typically they should be somehow related to each other so that the still-life scene reflects a common theme. Tripods are essential when shooting still-life scenes because you can position the camera in one spot and lock it in, then keep checking the viewfinder or LCD as you move back and forth making minute adjustments to the composition and arrangement. You'll probably want a wide depth of field, so use Aperture Priority or Landscape mode to dial in a setting of f/11 or f/22. Once you have perfected your scene, you can make adjustments to the lighting, either by bringing in some kind of light source (like a lamp or a reflector board) or by waiting for the perfect lighting to arrive (like golden sunlight coming through an open window). Take a few shots and then start over, rearranging the scene again and again until you're confident you have a good shot.

This still-life photo was shot with sunlight coming through a window. The sunlight wasn't falling onto the background, so the background was rendered into a very dark look that I like a lot.

Opposite: Photographing multiple animals together can be fun and can make for great pictures. This cat and horse obviously get along quite well together and enjoy each other's company.

Having Fun

I t's time to break some rules and try some fun things! Be prepared for some failures but also for some spectacular results with your photos.

Fun Lenses

If you own a DSLR, you have all sorts of options when it comes to choosing lenses that will give your photos a unique look. Some of these lenses won't be very useful in most situations, and some are rather expensive, but they can certainly add some punch to your photography!

■**Lensbabies:** I love Lensbabies. Lensbabies are little manual-focus lenses that are flexible. You can bend them and twist them to create bizarre-looking images that are sharp in one

Wherever you go, always have your camera with you and always be on the lookout for interesting subjects, details, compositions, and lighting conditions. Part of the fun of photography is never knowing what good shot you may fall into!

place and wildly blurry in others. Very fun. There are several styles to choose from.

- **Very wide-angle lenses:** Lenses with very short focal lengths (basically anything wider than 28mm) can produce fascinating effects in all sorts of situations. They can be used in landscape photography to take in a huge scene or for more close-up work to create interesting perspectives. Be aware, however, that these lenses cause a huge amount of distortion. Anything near the edges of the photo appears severely bent or twisted. The amount of distortion depends on how short the focal length is: a 14mm lens will

Quick Fact: Something Fishy

Extremely wide-angle lenses (around 12mm or less) are known as *fisheye* lenses because they produce a circular image with black vignetting around the edges. These are fun to play with, but they're not very useful for most situations, and they are *very* expensive.

produce far more distortion than an 18mm lens. If you enjoy working with short focal lengths, you might want to look into purchasing one of these types of lenses.

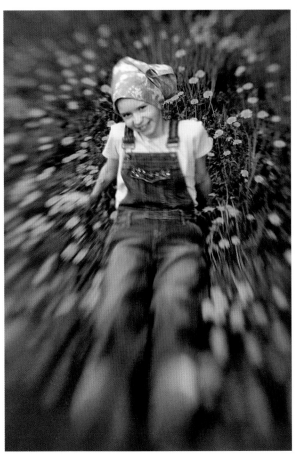

This is the kind of result you can get from a Lensbaby lens—streaks, blurs, and a sharp "sweet spot" to lure the viewer's attention onto your subject. Lensbabies are a little hard to focus with, though, as you can see from this picture. I meant to have the girl's face right on sharp, but I accidentally focused *just* behind her on the background flowers.

Here's a fun technique to try with your DSLR's zoom lens. Pick any subject, like the daisy I chose here, and place it in the very center of your photo. You probably should use a tripod for this trick. Zoom your lens out as far as it will go. Then, use aperture priority mode ("A" or "Av") to dial in a setting of about f/22. Set your ISO to its lowest setting (probably 100). Doing this forces your shutter speed to slow down. Then, at the very instant you take the shot, quickly zoom your lens in with your left hand as fast as you can. The result is the fascinating effect I've shown here.

Double Exposures

Some DSLRs offer a double exposure feature (usually found somewhere in the menu). This means that you can take two separate photos and the camera will blend them together into one image. Some cameras even let you do this multiple times (known as "multiple exposures") to create some interesting effects.

Here is a double-exposure picture using the "sharp/soft" effect. For the first exposure of the leaf, I focused the camera normally and made a sharp image. For the second exposure, I purposely made a very blurry shot by manually focusing the camera to the wrong position. When blended together, the two pictures make a pretty, dreamy-looking image.

One double-exposure technique that I really like is a "sharp/soft" photo. I make two exposures of the same object: one very sharp, the other slightly out of focus. I use a tripod to make sure that the camera doesn't move in between pictures. The result is a dreamy, glowing, hazy image that can be quite pretty. You can try this experiment with people too, if they can sit still enough between exposures.

Another fun idea to try is to make a double exposure-photo that shows somebody with his or her "lost twin." You'll need a simple background (a blank white wall is perfect) and a volunteer. Set your camera to double-exposure mode, have your subject pose in front of the wall, and take two separate shots, with the subject in different positions each time. The resulting photo shows the same person *twice* in the same photo, doing different things.

Self-Timers

We all know what self-timers are for: They're for taking group photos that include the photographer. He sets the

For this picture, I fastened a small point-and-shoot camera to the top of a long pole. Then I set the self-timer so that it would go off in ten seconds. During those ten seconds, I hoisted the pole up far over my head and tried to aim the camera so it was pointed somewhat downward and would capture a nice view of the surrounding area. The sun was going down and casting long shadows, which add to the photo's charm. (One of the long shadows belongs to me and the pole!)

> Self-timers can be fun if you
> use them in creative ways.
> Mostly I use them when
> I'm working alone as a way to
> get myself into interesting pictures.

camera up on a tripod, trips the timer, and runs like crazy to get into the group before the shutter opens.

Self-timers can be way more fun than that if you use them in creative ways. Mostly I use them when I'm working alone as a way to get myself into interesting pictures. If I'm shooting

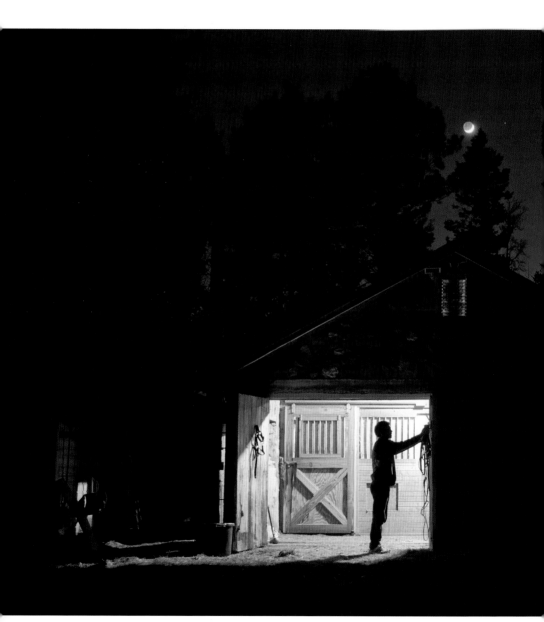

an attractive scene and I'd like a human in it somewhere and no one is around, I just use the self-timer and go. Your camera's menu may give you options on how long the timer waits before releasing the shutter, usually in increments of five, ten, fifteen, twenty, and thirty seconds.

Another fun thing to do is to mount your camera on a very long pole or a tripod with the legs extended all the way but not folded out. Trip the self-timer, and while it counts down, lift the camera straight up into the air as far as you can reach. You can get some fun high-perspective views this way.

Night Photography

Most people don't take pictures at night because, hey, let's face it, "It's too dark to take pictures." The fact is, it is only too dark for *some* kinds of pictures. Sure, you wouldn't go out and try to photograph a nice portrait in the dark—or any kind of action photography either—but for certain subjects, things get even more interesting after the sun goes down!

- **Buildings:** Taking pictures of buildings at night is a blast. The best time is right around dusk, when there is still a little bit of light leftover from the sunset to cast a slight bluish glow on the surrounding area, but it's already dark enough that people inside the building have their lights on. Your camera's exposure meter should get things about right, but it may overexpose a tad, trying to make the darkness lighter. Use exposure compensation to darken the image by -1 or -2.

This is an example of the kind of picture you can get when photographing buildings at night. I put my DSLR on a tripod and used the self-timer so that I could get in this shot. I had the added benefit of being able to include a crescent moon and the planet Venus peeking up over the tree line. I had to stand very still in this photo because I was using a shutter speed of eight seconds.

Here are two different versions of star trails. The top photo used an exposure of about four minutes, while the bottom photo required an exposure of over an hour. Both versions are quite pretty, I think.

There was an interesting moonrise on the night I took this photo. After making a few up-close images of the moon, I switched to a shorter focal length to take in more of the scene, and I used the light-painting technique to add more color to the photo.

■**Star trails:** This is a beautiful technique. Wait for a clear, moonless night. It helps if you can get away from buildings and lights. Out in the middle of an open field is perfect. Set your camera on a tripod and use a mid- to wide-angle lens (maybe 28mm to 40mm) to take in a nice large chunk of night sky. Manually set your focus to infinity and leave it there. Set your ISO to around 400 (you can experiment to find just the right setting of sensitivity versus noise for your particular camera), your aperture to its widest setting, and your shutter speed to "B" or "Bulb." On this setting, your camera will leave the shutter open for as long as you hold down the button (you can also purchase a cable-release with a lock feature that can hold the button down for you). Experiment with exposures from a few minutes long to as much as a few hours.

As the Earth turns, the stars will leave long, curving streaks across your photograph. The longer the exposure, the longer the star trails. Very pretty.

■**Light painting:** Light painting is another fun technique to try out at night. Start by finding an interesting but immobile object, such as a tree, building, fence, or car, to photograph. Set up your camera on a tripod and use an ISO rating of 400 to 800, then set your shutter speed to about fifteen seconds. After you release the shutter (and while the camera is in the process of "taking the picture"), use a strong flashlight to "paint" all parts of the object. Keep the flashlight's beam moving around quickly; if you shine the light on one place for too long, that area will overexpose. The resulting image will be a unique view of the subject.

Kite Cameras

Here's something fun—but potentially risky to your camera. If you have a good location for kite flying, you might want to try strapping a small digital camera onto a kite for some daring aerial photography. It's always a good idea to have an adult's supervision if you try kite-camera flying. Here are a few ideas to help you along:

- **Use a cheap point-and-shoot.** Obviously, the weight of the camera is going to be a big concern when trying this out. Even large kites can't carry very much of a load without degrading their flight performance, so a tiny point-and-shoot camera will be your only option. And this is a good thing anyway because there is always going to be a risk of a camera-destroying crash, either from hitting the ground or a tree. I wouldn't use a good camera for this experiment; only use a cheap (or old) one. Also, try using lithium batteries rather than alkaline for this because the lithiums will give you better performance at less weight.

- **Use a self-timer or video mode.** Aside from actually getting the camera up in the air, the main dilemma is that there will be no one around to push the shutter button. No fear. You have two options to handle this problem. The first option is to use your camera's video mode. Start recording just before you launch the kite (make sure you have an empty card with plenty of room for good video), and then let it go. The camera will film all through its flight. After touchdown, use a video-editing program like Windows Movie Maker or Apple's iMovie to capture some of the very best frames from the video and turn them into JPEGs that you can print and share. (The actual movie will probably be too sickening to watch!) The problem with this is that the video frames won't be of a particularly good resolution. As a second option (and this option is especially good if you're interested in ultimate kite-camera quality), you can use a camera that offers an "Interval Timer" mode. This is a mode that lets you set the camera to take a picture automatically every few seconds, regardless of whether or not someone presses the shutter button. Again, use

Don't forget to shoot from below as well and take pictures of the kite. Blue skies, clouds, and the cheerful colors of a kite can make for very pretty pictures.

an empty card so that the camera doesn't run out of room just when you get the kite to a nice altitude.

- **Use a fast shutter speed.** The kite is going to be bouncing around and weaving this way and that. If your camera offers a Shutter Priority or Sports mode, use it to force the shutter speed up to 1/500 or higher. If you don't do this, you're going to get frames that are nothing but streaking blurs.
- **Tie it on well!** You probably can't attach the camera to your kite safely enough. The more securely you can attach it, the better. I don't think many cameras would survive falling from any significant altitude!
- **Try to bring it down softly.** Once your camera has been up for a good amount of time and you're sure you've got some spectacular aerial images, pull the kite in smoothly and slowly. You're trying to avoid an abrupt impact with the ground. If the battery door opens or the card falls out, you may corrupt the card and lose all those great shots.

Here are two composite images that I stitched together using photo-editing software. Each individual picture is one still frame from the video that my tiny kite camera filmed. After the flight, I selected the best stills and made a larger view of the surrounding area.

Special Computer Effects

There are all kinds of amazing things you can do to your photos once they're on the computer. Here are two of my favorites:

- **De-saturate all colors except for one channel.** Some photo-editing programs allow you to control the saturation of every color individually. For instance, you might be able to increase the saturation of all the greens in your photo while toning down on the blues (this kind of enhancement is what the tool is designed for). However, one technique that is very popular is to de-saturate all the colors except one. This leaves you with an image that is almost entirely black and white, with only a few items left in full color. For instance, if I took a photo of a girl in a pink shirt carrying pink flowers, I could make the entire image black and white except for the pink items. This makes for a very attractive, distinctive image.

- **Blur certain areas of the photo.** Your photo-editing software may have a blurring tool that can be used globally (blurs the whole picture) or locally (blurs only the parts you want blurred). You can use the local blurring tool to "paint" a softness around the subject of your photo while leaving the subject sharp. This creates a dreamy, hazy look that can be very pretty. (Ironically, the blurring tool may be built into the "sharpness" adjustment of your photo-editing software. Look there if you can't find it anywhere else.)

Remember: Don't play with your original photo! Be sure to experiment *only* with a copy (a Save As version) of your photo. If you were to save some horrible mistake to the original accidentally, you would never be able to get the picture back to its normal state.

The best special effects are those that help enhance a picture, not just make it look odd. For fun, I dropped all the colors except yellow, and I think this gave an average photo an added boost. Of course, I saved the original full-color version as well.

Remember: Don't play with
your original photo!
Be sure to experiment *only* with a copy
(a Save As version) of your photo.
If you were to save some
horrible mistake to the original accidentally,
you would never be able to get
the picture back to its normal state.

Note that most special effects are best used sparingly. You can overdo them very easily.

Black-and-White Photography

Black-and-white photography has regained some popularity in recent years, partly due to the advent of digital cameras. With film cameras, you have to decide ahead of time if you are going to shoot color or black-and-white film. You don't necessarily have to make this choice with digital photography. Let's take a look at two ways that a digital camera can give you black-and-white images:

- **Shoot color all the time.** Any color picture can be transformed into a black-and-white image by using photo-editing software. You open the

picture file, look for a feature or tool called "grayscale" or "monochrome," and your color image is immediately transformed into the classic black-and-white look. Alternatively, you can drag your software's saturation slider all the way to the left, which takes away all colors and leaves you with basically the same look.

- **Use your camera's black-and-white function.** The other way is to have your camera give you black-and-white pictures straight out of the box—um, card. Most cameras have a feature—usually buried away deep within the camera's menu—that will give you black-and-white JPEGs right away without any software assistance later. The advantage of this method is that you can see the black-and-white effect on your LCD at the time of shooting, which can help you learn to "see" better in black and white. You can visualize how a particular scene might look when viewed as black and white. The only real disadvantage (and it is a big one) is that you can't ever take a black-and-white JPEG and turn it into a color image later. You can always turn a color image into a black-and-white image but never the other way around. If you happen to get the most fantastic photo ever and it was taken as a black-and-white JPEG, the colors can never be recovered.

I used side lighting to make this portrait, with the light source coming from the left and falling off toward the right. Then I placed the girl's eyes (the focal point) right on one of the rule-of-thirds points. I shot using RAW but with my camera set to black and white as well. All of this came together to make a portrait that I really like.

In addition to allowing any color photo to be made into a black-and-white shot, most photo-editing software also offers you a way to make images appear old and faded, or with a sepia tone. This can be a fun feature.

Unless . . .

Unless you shoot black-and-white *RAW* images! If you do this, the photos on the back of your LCD will appear in all-out glorious black-and-white, but when you get them home to your RAW converter, you can, at any time, *undo* the black-and-white filter and return the tones of your photo back to their previous state of living color. As I've already stated, RAW files require more care and feeding than JPEGs, but if you don't mind, this option is really the best of both worlds.

No matter which way you achieve your black-and-white digital photos, it is unlikely that they are going to be perfect when they come straight out of the camera. Generally, the best black-and-white images are achieved by careful consideration and tweaking of the tones. Black-and-white photographers often strive to make sure that the darkest areas of the photo (the "blacks") are full of true, deep tones, while the lightest areas (the "whites") are made up of clean, bright highlights. Your photo may or may not look this way right off the bat. Most likely, it will have a fairly bland appearance, with most of the tones in a kind of middle gray. Try opening the image in your photo-editing software and working with the Tone Curve or Levels Adjustment tools to help achieve the perfect look.

Black-and-white photography can be a nice addition to your toolbox of tricks. If you enjoy the look, you may find yourself going to this style more and more. Have fun!

Underwater Cameras

Taking pictures underwater is a lot easier now than it used to be, simply because we can fit so many more images on a single card than we could fit on a single roll of film. Underwater photographers used to be limited to thirty-six images before having to come out of the water to change rolls. So pop in a card and get ready to have some fun!

There are many point-and-shoot cameras made now that are reasonably waterproof, to a certain depth. This means you can take them underwater without any special protection. This can be great fun, and I wouldn't hesitate to try it out. However, I would recommend that you be cautious about exactly how deep you take such a camera; the manufacturer's "guaranteed depth" may be a little optimistic. To stay on the safe side, I wouldn't push the camera anywhere close to its maximum safety depth. You can still have plenty of fun with these cameras closer to the surface. And, of course, an underwater camera can double as a perfectly good camera for normal out-of-the-water shooting

You can also purchase underwater housing for just about any camera, both point-and-shoots and DSLRs. The advantage here is that you can use the camera you already own, although the plastic housing may prevent you from handling every button and feature your camera offers.

One difficulty about taking pictures underwater is that water tends to "bend" light, making things seem closer to you (and your camera) than they really are, which can throw off autofocusing. To help out, try using a wide-angle focal length most of the time, to make sure that your depth of field stays nice and wide.

Silhouettes

Silhouettes are great fun and easy to do. As we saw in chapter 4 about lighting, a silhouette is a photo where the light source is coming from behind the subject. In other words, the photographer is looking into the light source, and the subject is in between the light source and the camera. You can create situations like this by working at sunset, when the sun is down low and can be placed behind a subject, or by having a subject pose just inside the doorway of a building while you photograph from inside.

When these dramatic clouds started to roll in, I quickly ran inside and got the camera. The silhouette effect worked nicely here because the large clouds (which take up most of the picture and, therefore, are what the camera tried to set the exposure for) were much brighter than the people. This photo started out as a color image, but after viewing it later, I decided it would be more powerful in black and white.

EXHIBITING YOUR PHOTOS

Eventually, you're going to want to do more with your photos than just look at them on the computer. E-mailing them and working with them in photo-editing software is great, but the time has come to let the world see how wonderful they are! Time to get those shots off the machine and out in front of a wider audience.

Printing
Looking at photos on the computer is nice, but the ultimate goal is to have a really nice print to hold in your hands or hang on the wall. Creating a good print takes effort, though, so before you rush off and push "print this picture," let's take a look at a few of the issues facing those who wish to create a nice print.

Printing at a Lab
You can pay a photo-processing lab to make a print for you, and this transaction is fairly straightforward. Most businesses accept almost any type of memory card or images on CD: You just drop off your media and tell them what sizes and quantities you want, and they do the rest. You might possibly be able to find a photo machine located in a

Before long, you'll be ready to show off your best work.

photo store (or other location) that allows you to do the same thing—insert your memory card or CD and then choose what pictures and sizes you want to print, all for a small fee. However, these types of machines might not be able to print pictures larger than 5×7s . Another possibility would be to use an online photo lab (such as www.mpix.com). These sites require you to upload your pictures to an account, where you can then pick out print sizes and quantities. The finished prints are then mailed back to you. A possible disadvantage to this choice is the time required by you to upload large image files (those capable of producing quality prints), but if you have a fast Internet connection or only a few photos you wish to print, this might be a good choice. In any of these cases, you almost certainly won't be able to print RAW images; you'll have to

If you want to make very large prints, you will have to work with a photo lab because most home printers are limited in the size of paper on which they can print.

create TIFFs or JPEGs with your RAW converter software first. If you shoot JPEGs to begin with, then you're all set.

The biggest advantage to having a print made for you is the terrific quality. You usually get a more attractive print that is sharper and more durable than one from a home printer. The biggest disadvantage to printing at a lab is the cost, although this price is usually quite affordable, especially for small prints (like those smaller than 5×7).

Printing at Home

Of course you can make prints at home as well, on your own printer. There are some advantages to this: You can make as many prints as you want, whenever you want, and usually up to sizes as big as 8×10 or even larger. You don't have to wait for a machine or a lab to finish the job for you, so some time is conserved.

The problems with printing at home are the cost of the ink and the lower print quality. Even if you use high-quality photo paper (and you should) your inkjet printer probably won't be able to compete with a lab at making top-quality prints. However, when printing small photos that are only going to be used for fun projects like photo albums or for sending to Grandma, most people won't be able to tell the difference between a home print and a commercially made one.

If you can muddle your way through it, it would probably be a good idea to read your printer's manual (sometimes located

Be sure to let your homemade print dry sufficiently before handling it, and try to keep it as flat as possible during the drying process. After that, it's ready to frame or mount.

Here I've made a homemade print, but it has a yellowish cast—not like the bluer, greener version I saw on my computer's monitor. I should have made a tiny proof print first to check the colors before making this large 8×10.

on the printer's installation CD), so you can learn the best way to coax top quality out of every print. You can do this by following the manufacturer's recommendations on topics like print speed (best quality prints will take longer), ink brands (many companies recommend their own ink, and it's usually wise to follow this advice), and paper type. Some printers only print photos on a standard-size piece of paper—like your typical 8½×11-inch paper—leaving you to do the tedious job of cutting away all the excess white space around your print.

Other printers accept photo paper already sized to the dimensions of typical prints—4×6, 3×5, or 5×7—and then create an image on this paper "full bleed," meaning the photo bleeds to the edges, without any extra white. This saves you a lot of time and looks a lot better. Your printer's manual will be able to explain all the details of this and other useful functions.

Hey, This Print Doesn't Match the Screen!

Once you have a print in your hands, you're probably going to notice that its colors do not perfectly match the colors on your

computer screen. In some cases, the difference between the print and the screen can be quite dramatic. Skies that appeared to be dark blue on the computer (or on your camera's LCD, for that matter) might appear to be a lighter blue on the print. Reds might look too orange or too maroon; greens may look too bright or too yellowish. Or, the colors may appear to be accurate, but the tones are off; the whole print may seem too dark or too light when compared to the screen. Blacks might be grayish, or highlights too dull. What's going on here?

What's going on is that your printer (or the printer at the lab, if you paid to have your print made) and your computer screen have not been calibrated, or adjusted, to the same standard. Without calibration, they both have a different idea of what a true red looks like, or a true blue, or a true black. They are each going to represent colors and tones in a slightly different way.

There are several things you can do when faced with this dilemma.

- **Do nothing.** If your print looks nice, and the colors and tones are acceptable, it may not matter if they don't look exactly like what is on the screen. In some cases, this could even be a *good* thing because it's possible the printer's calibration will give you nicer colors anyway. If you have your prints made at a lab, this could be especially true. One problem with doing nothing is that you have to give up precise control over your images. You can do all kinds of post-processing work on your photo-editing software and spend a lot of time perfectly balancing the colors and tones, only to have all that go out the window when you have the print made.
- **Make proof prints.** The next solution—one step up from doing nothing—is to make a series of proof

(practice) prints in small sizes but on the same paper and at the same print quality you intend to use in the final print. Make the first proof print the way you would normally, and then examine it. Is it too dark? Too green? Too orange? If so, go back to the computer and make counter-adjustments to the image, based on your print. If the print is too dark, lighten the image on the computer *even if it seems wrong on the screen.*

When you get right down to it, an image on a computer screen is created in a very different way than an image on a print.

Do the same to colors: Take away some green or blue or add some red or whatever it takes to counter the inconsistencies between the print and your screen. Then make another proof print with these changes (again, at a small size so you don't waste ink), and compare how you did. Chances are, the proof will look pretty good and a lot closer to how the image *did* look on the screen, before you messed with it. You can continue to make proofs and make changes until you have achieved the effect you want, and then make your final print at your desired size. The problem with this solution is that you are, in effect, working "blind." You can't see if the changes you are making are correct until you have the proof in your hand, and this trial-and-error process is very time-consuming.

Accurate colors are important to me, so I always keep my computer screens calibrated. It only takes a few minutes and will keep your monitor correct for about two weeks. Check out products by ColorVision (maker of the "Spyder") or Huey if you're interested in calibrating your own monitor.

However, over time, you may get a feel for how your printer prints. If it consistently makes prints that are too dark, and you know this, you can plan ahead and avoid the proof-print option.

- **Calibrate your monitor.** This is probably going to help a lot. Calibrating (or adjusting) a monitor requires a device known imaginatively as a "spider." The spider is a cute little device that plugs into your computer's USB port and then dangles in front of your screen like a spider climbing down its wire "web." The spider and its software then run the computer screen through a series of color tests, precisely examining the reds, blues, greens, blacks, whites, and grays. Then the spider makes recommendations to your computer about how it should display colors and tones. Calibrating is then repeated every

month or so, since monitor colors may drift away from their correct settings over time. I calibrate the monitors on my desktop and laptop computers every two weeks, since correct colors are very important to me. The only problem with this solution is the cost. Spiders can cost up to a few hundred dollars for a good one, and although cheaper ones (less than one hundred dollars) are certainly around, they may not offer as much control as the more expensive versions.

However, even after going through all of these options, your print will probably still look different from your screen, although it may be very close. But you may have to live with it; you'd be very hard pressed to improve the difference any further. The reason is that when you get right down to it, an image on a computer screen is created in a very different

way than an image on a print. A computer screen creates a glowing image made up of three colors—red, blue, and green (called RGB)—projected at different intensities. A print is a permanent image made up of four colors—cyan, magenta, yellow, and black (called CMYK)—and will vary in appearance depending on the paper used and the conditions viewed under. So no matter how hard you try—and believe me, photographers try very hard—you may never reach that plateau of the perfect match between print and screen, but you can achieve excellent results nonetheless by using the tips we discussed.

Photography Contests

Photo contests, whether through the mail, online, or at a fair, can offer you a fun way to see just how well your talents stand up against competition. Contests can also be great places to find ideas of what to shoot and can offer you a goal to aim for. Here are a few ideas to help you get started.

Carefully study the rules and categories before entering any photo contest. Looking over the various categories may also give you new ideas for photos to try.

Follow the Rules

The first thing you want to do when entering a photo contest is to read the official rules completely. They are probably long and contain a bunch of information that is quite boring, but try to read and understand the whole thing anyway. Failure to comply with the simplest formalities (even those that have nothing to do with the quality of your photos) can be grounds for immediate elimination. Things to watch out for include the following:

Type and size of image

If the contest calls for prints, make sure the ones you submit are within the correct size limits. If the contest rules state that a photo may not be larger than 8x10 , and you enter an 8x12 (it happened to me once), the judges can set it aside and ignore it, regardless of how good it may be. If the contest only wants to see lab-quality prints and you enter something printed on a home printer (even though it may look fantastic), the entry could be disqualified.

If you are entering an online contest, the rules may be very particular with regard to file type, resolution, and size. Try to follow these directions exactly. If the contest wants JPEGs (and it almost surely will), don't, obviously, send a TIFF. There may be minimum limits on image dimensions, such as, "Images must be at least 1,600 pixels long on the longest edge," or something similar. This is because the judges want to be able to evaluate all the photos accurately, and they can't do this if you send them a low-res photo with tiny dimensions. If this is the case, I would recommend keeping your image dimensions a bit over this number but not way over. Say 1,700 or 1,800 instead of right on 1,600. If there is a limit to file sizes like, say, 5 MB or less, experiment to find just the right amount of JPEG compression to shove your image file size just under the limit. This will keep you

Here's a selection of various photo projects, all mounted, labeled, and ready for exhibition. Some contests and categories will require specific caption information, while others may not.

within the rules but will ensure that your image looks as good as possible for the judges. Also be aware that if you are fortunate enough to win, the contest may want a much higher resolution version of the winning photo, for publicity purposes.

Mounting

If you are entering pictures in a county or state fair competition, you will need to supply some kind of photo mount. For categories involving only one photo, such as a portrait or best work category, framing may or may not be allowed. If you do decide to use a frame, make sure the glass is clean and not dusty and that it adds to the charm of your photograph and is not a distraction. You want the judges to notice the photo, not the frame. I've seen many competitions where the photos displayed in big frames did not compete well against those mounted otherwise, so framing is not necessarily an advantage. For mounting

without a frame, make sure that the size and color of the mounting board are within the rules. If the contest calls for photos to be mounted only on a white board—or only light pastel colors—and you enter a photo mounted on a black background, your photo may not place well (or may not place at all). Again, you want the mounting board to help and not hinder your photograph, so this means no writing or "decorative" touches, and no "creative" cropping. Dull as this may seem, you want the judges to be looking only at your photos, and general neatness helps to achieve this. Labels or captions, if required, should also be neatly handwritten or, preferably, printed.

Manipulation

Some contests do not allow or will discourage any computerized photo manipulation by the photographer. In these cases, they are usually talking about doing extremely weird things to your photos, like creating a person with two

heads or designing a flying poodle hovering over Seattle. General photo enhancing, including white-balance adjustments, general color saturation, sharpening, cropping (although some contests may discourage cropping), and adjustments to tone are almost always allowed and encouraged. Check the contest's rules to determine exactly what is allowed or not.

Who keeps the picture?

Some contests mail your print back to you, others do not. Read the rules carefully to determine just who will "own" the print after the contest. You may find that your print becomes the property of the contest, regardless of whether or not you win, and you may or may not be okay with this. Or the rules may state that you keep your image, but the contest may use a copy of it later for any purpose they desire. You want to be aware of these details before making any commitment to the contest, and make sure you agree with them. If the contest plans to return photos, they will probably only do so if you include a self-addressed stamped envelope (SASE) along with your entry.

Tips for Winning

People say all kinds of things about competition: "I was just in it for the experience," or "I'm just doing it to have fun." These are great reasons, but come on; we all enter contests because we want to win!

At a small size, this photo looked nice. But once I examined it at a large magnification on the computer screen, I could see that the foal's face was not perfectly sharp. This shot would be fine for some uses, but it should definitely not be considered for competition. Always check your pictures for perfect sharpness before entering them in any photo contest and before printing them at any significant size.

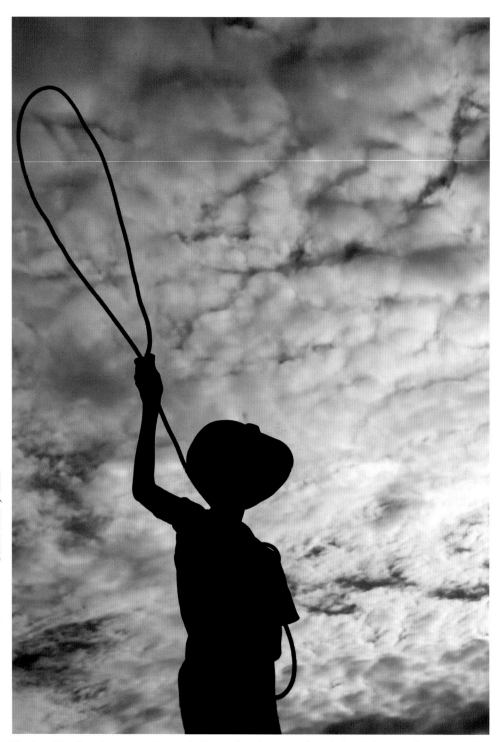

There's nothing like a nice print straight out of a high-quality printer. You will get the best-looking print from a printer that has multiple ink cartridges, such as a printer that has separate cyan, yellow, magenta, and black inks. But don't be afraid to try printing a photo on a lesser-grade machine; you might still be pleased with the results.

I know I do. Here are a few ideas to increase your chances of pulling off the big win.

■**Check out last year's winners.** If the contest has a website, it will very likely have a page showing previous winning photographs. Examining these photos can be quite helpful to you. It gives you a clearer idea of what the judges are looking for, what they like, and what styles they seem to appreciate.

■**Narrow down your choices.** The contest may allow multiple entries. Theoretically, the more photos you send (within the allowed limit), the greater your chances of succeeding in the contest. But this doesn't mean you should bombard the judges with photos that aren't up to par. Carefully edit your contest submissions, thinking about which photos truly show your best effort and talent. Reject any photo that is not excellent in all respects ("But it's only a *little* blurry!") before the contest.

■**Keep within topic.** There may be restrictions as far as what the subjects of the photos may be. While "freestyle" contests exist (where all photos compete against each other, regardless of topic), more often you will find that contests are broken up into particular categories. These might include a landscape photo contest, a portrait contest, a wildlife contest, and all kinds of others. You might find other contests that offer a broader range of subjects but all within a specific style, such as an all black-and-white photo contest or a "nature subjects" contest. Obviously you want to send only images that are appropriate for any given contest. Doing otherwise is a complete waste of time—you won't win a portrait contest with a picture of a waterfall, no matter how good it may be.

■**Enter in categories you enjoy.** If you are entering your photos in a county or state fair photo competition, there will be a long list of categories to choose from, far more than you will want to enter. If this is the case, pick out only the categories you have an interest in because you are more likely to perform well in those areas.

Don't bombard the judges with photos that aren't up to par. Carefully edit your contest submissions, thinking about which photos truly show your best effort and talent.

■**Get your entry there on time.** Contests deadlines exist for a reason. If the contest deadline is November 1 and your entry doesn't arrive until the 15th, you're going to be out of luck. It will probably end up in the trash, unopened. Make sure your entry has plenty of time to get to its destination, in case the mail is slow. There is no reason to wait until the last minute and then scramble to get your entry together.

■**Package it well.** If you are entering a mail-in contest (i.e., mailing a print) you want to be sure your entry arrives to the judges looking great. Use a sturdy envelope with a piece of cardboard inside to keep the photos from being bent and banged around in the mail. Make sure everything is neat and tidy and that your name and address (if the contest requires) are neatly written or printed on the back

of each print. I would advise against writing directly on the back of a photograph because if you push even a little too hard, you could damage the *front* (image) side of the photo. Instead, write or print on a blank adhesive label, wait for the ink to dry, and then apply that label to the print. Very clean and very impressive. Find out if you need to send along the contest entry form (you probably do), and make sure it is filled out completely.

- **Enjoy your winnings!** Remember that even if you don't win, it doesn't necessarily mean there is anything wrong with your photos; the judges

were just looking for something else, or maybe yours just wasn't the best that day. Part of the fun of competition is trying over and over, refining your work, and improving all the time. Never let a bad showing discourage you. On the other hand, if you do win, enjoy the satisfaction of knowing that your photo was the best to that judge on that day and that you are becoming a really good photographer—in fact, you are an award-winning photographer. Think how far you've come from your early pictures.

■ **And above all . . .** Have fun, and keep shooting!

That's it for now. Learning the art of photography is a lifetime process and one that you will hopefully enjoy even more with the information I've offered through this book. Now head out there and keep taking great photos!

Glossary

aperture: The small hole built into a lens that controls the amount of light that enters a camera. A large aperture (with a small f/ number like f/4) lets in more light than a small aperture (with a large number like f/22).

background: The area in a photo behind the subject.

camera shake: Blurring in a photograph caused by camera movement.

compression: A way to make an image file smaller by throwing away redundant information. A highly compressed image may lack detail, but a small amount of compression can make an image file much smaller without losing necessary quality.

corrupted card: A camera card that has become damaged in some way, resulting in the loss of some or all of the photo files stored on it.

depth of field: A way of describing how much of a photo is acceptably sharp. A photo with a shallow depth of field is only sharp in one specific place. A photo with a wide depth of field is sharp everywhere.

EXIF data: Information that a camera stores in an image file along with the photograph, containing such things as the date and time that the photo was taken, the camera settings that were used, and the lens information. EXIF stands for exchangeable image file format.

exposure: The amount of light exposed to the camera's sensor. A photo that is too dark is said to be "underexposed"; not enough light reached the sensor. A photo that is too light is "overexposed"; too much light reached the sensor. Photographers also use the word *exposure* to mean "a photograph," as in, "I made several exposures of the scene."

exposure compensation: A camera setting used to make photos appear either lighter or darker than the camera's current suggestions.

exposure mode: A way to tell the camera what kind of scene you're photographing so that it can perform to the best of its abilities.

exposure value (EV): Also known as a stop. An EV is one "step" of exposure. Adding an EV adds brightness to the photo.

focal length: The length (measured in millimeters) of a lens.

focal point: The most important area of a photograph, the spot that the viewer's attention goes to first.

focusing point(s): The little dots inside a camera's viewfinder or on its LCD screen that can be used to autofocus on certain areas of the photo.

foreground: The area in a photo in front of the subject.

format: A way to delete everything on a camera card and then refresh the card for repeated use. Only do this after your picture files are safely put away on the computer.

histogram: A graph on the LCD screen that shows the overall brightness of an image.

ISO (International Organization of Standards): A number that determines how sensitive to light your camera's sensor is. A high ISO number (like ISO 1600) is very sensitive and can be useful in dim lighting, but it will produce grainy, noisy images. A low ISO number (like ISO 100) reacts much slower to light, but it provides a much cleaner, noise-free image.

JPEG: A common image file type. JPEGs save room on your computer or card by "throwing away" unneeded information in the photograph by lumping similar pixels and colors together as one. JPEGs are very handy for everyday work but are not always used by professional photographers.

LCD (liquid crystal display): The little screen on the back of your camera. Use it to take a look at all your great photos!

lens: A piece of glass that gathers light, focuses it, and directs it into the camera and onto the sensor.

light meter: A device inside a camera that examines the brightness of light in a scene and then makes an exposure recommendation based on its findings.

megapixels: The number of pixels a sensor has available to record on. More megapixels means a higher resolution photo with more information.

noise: Little speckled grainy bits in a photo, often in dark areas, but they can appear anywhere. Noise is usually caused when a photographer uses an ISO number that is too high, but it can also appear in photos taken at night.

noise reduction: A way to "smooth" out noise and make an image look cleaner. Noise reduction can be applied by some cameras when the photo is taken or later using image-editing software.

optical drive: A CD-ROM or DVD-ROM drive, usually built into a computer. A recordable optical drive can be used for backing up photos or for sharing them with Grandma, if she owns a computer.

post-processing: The act of doing some kind of tweaking to a photograph after it is taken, usually with computer software.

RAW: An image file that has not been "finished" by the camera but contains all the information needed to do so. RAW image files require special conversion software in order to be viewed and processed by the photographer, but they give the photographer more control than would otherwise be possible. After processing, RAW images are converted into a more common file type, such as a TIFF or JPEG.

resolution: The number of pixels (dots) that make up a photo. A high-resolution photo has many pixels and can be reproduced at a large size without losing detail. A low-resolution photo can only be reproduced at a small size before detail is lost.

rule of thirds: A composition method used to arrange attractive photographs.

selective focus: A term used to describe a photograph that has only one object in sharp focus; the background is blurred. This draws more attention to the subject and can help disguise a busy background.

sensor: The electronic device that senses or "sees" light coming through the lens and records it as electrical signals. These signals are then converted into a computer file, where the photographer can do any number of great things with them, including printing and e-mailing. The sensor sits in the same position that film does in a film camera.

shutter: A small door on the camera that shades the image sensor from light. The shutter stays closed all the time, except when you open it by pressing the shutter release. Opening the shutter for a short time (like 1/500 of a second) lets in only a small amount of light and can make moving objects appear frozen in time on the photo. Opening the shutter for longer periods of time (like 1/30 of a second) lets in lots of light but can make moving objects look blurry.

shutter lag: A delay between the time when you push the shutter button and when the camera actually takes the picture.

shutter release: The button you press to take a picture. Photography would be challenging without it.

stop: Also known as an exposure value. A stop is one "step" of exposure. Adding a stop adds brightness to the photo.

subject: The topic of a photograph, the main thing a viewer is supposed to look at.

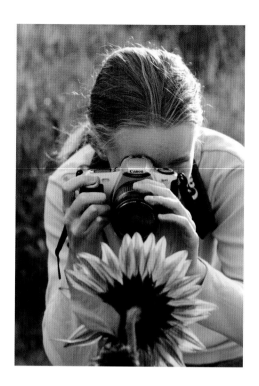

telephoto: A focal length or type of lens that makes distant subjects appear closer. It is the opposite of a wide angle.

temperature: The "warmth" or "coolness" of the lighting used for a photograph.

TIFF: A common image file type, often used for archival or professional purposes.

viewfinder: The small window on a camera that you look through to see what you're taking a picture of.

white balance: A camera setting used to make sure the camera records light at the desired color or "temperature."

wide angle: A focal length or type of lens that can take in a very large view of the area all around the photographer. It is the opposite of a telephoto.

RESOURCES

4-H
The main 4-H organization site
http://4-h.org

Adobe
Provider of photo-editing and organizing
software
www.adobe.com

B&H Photo and Video
Supplier of cameras, lenses, and other
photographic products
www.bhphotovideo.com

Calumet Photo
Supplier of cameras, lenses, and other
photographic products
www.calumetphoto.com

Canon
Camera manufacturer
www.usa.canon.com

Lensbabies
Maker of specialty soft-focus lenses
www.lensbaby.com

Mpix
Online photo lab
www.mpix.com

Nikon
Camera manufacturer
www.nikonusa.com

The Pod
Makers of beanbag tripods
www.thepod.ca

SmugMug
Photo-sharing website and online lab
www.smugmug.com

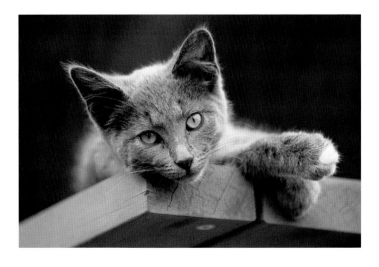

INDEX

ABOUT THE AUTHOR

Daniel Johnson is a full-time professional photographer and writer whose photographs appear in books, magazines, calendars, and greeting cards. He photographs all aspects of farm life from livestock to farm kids and particularly enjoys photographing horses and dogs. As a 4-H alumnus, he still enjoys helping young photographers with their projects. Dan lives on Fox Hill Farm in far northern Wisconsin where the vigorous winters and beautiful summers offer fantastic photo opportunities. Some of Dan's work can be viewed at www.foxhillphoto.com or on the Fox Hill Farm blog at www.foxhillphoto.blogspot.com.

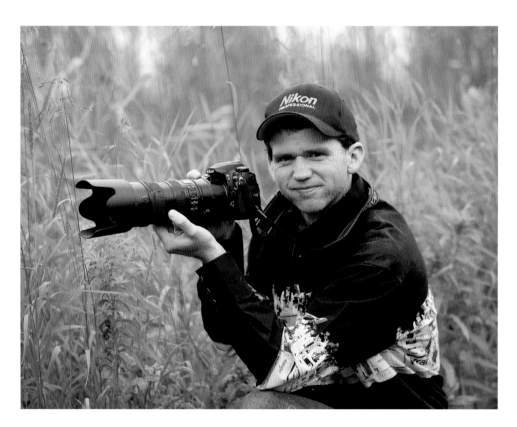